DIGITAL
Photography
Q&A

REVISED AND UPDATED

GREAT TIPS AND HINTS FROM A TOP PRO

Book Design: Sandy Knight, Hoopskirt Studio
Cover Design: Thom Gaines
Production Coordinator: Lance Wille

Library of Congress Cataloging-in-Publication Data

Davies, Paul, 1950-
 Digital photography Q & A : great tips and hints from a top pro / Paul
Harcourt Davies. -- Rev. and updated, 1st ed.
 p. cm.
 ISBN 978-1-60059-483-0 (pbk. : alk. paper)
 1. Photography--Digital techniques--Miscellanea. I. Title. II. Title:
Digital photography question and answer.
 TR267.D375 2009
 775--dc22
 2008045445

10 9 8 7 6 5 4 3 2 1

First Edition

Published by Lark Books, A Division of
Sterling Publishing Co., Inc.
387 Park Avenue South, New York, N.Y. 10016

Distributed in Canada by Sterling Publishing,
c/o Canadian Manda Group, 165 Dufferin Street
Toronto, Ontario, Canada M6K 3H6

Distributed in the United Kingdom by GMC Distribution Services,
Castle Place, 166 High Street, Lewes, East Sussex, England BN7 1XU

Distributed in Australia by Capricorn Link (Australia) Pty Ltd.,
P.O. Box 704, Windsor, NSW 2756 Australia

If you have questions or comments about this book, please contact:
Lark Books
67 Broadway
Asheville, NC 28801
(828) 253-0467

Manufactured in China
All rights reserved

ISBN 13: 978-1-60059-483-0

For information about custom editions, special sales, premium and corporate purchases, please contact Sterling Special Sales Department at 800-805-5489 or specialsales@sterlingpub.com.

DIGITAL
Photography
Q&A
REVISED AND UPDATED

GREAT TIPS AND HINTS FROM A TOP PRO

PAUL HARCOURT DAVIES

LARK BOOKS

A Division of
Sterling Publishing Co., Inc.
New York / London

DIGITAL Photography Q&A

FOREWORD · 10

───── **PART TWO** ─────
TAKING DIGITAL PHOTOS · 44

Acknowledgment

Grateful thanks to members of my family and to friends who patiently allowed themselves to be used as models and generously supplied photos to fill gaps.

The fun starts here! ▶
There is no limit to the fun and to the great pictures you can produce using a digital camera.

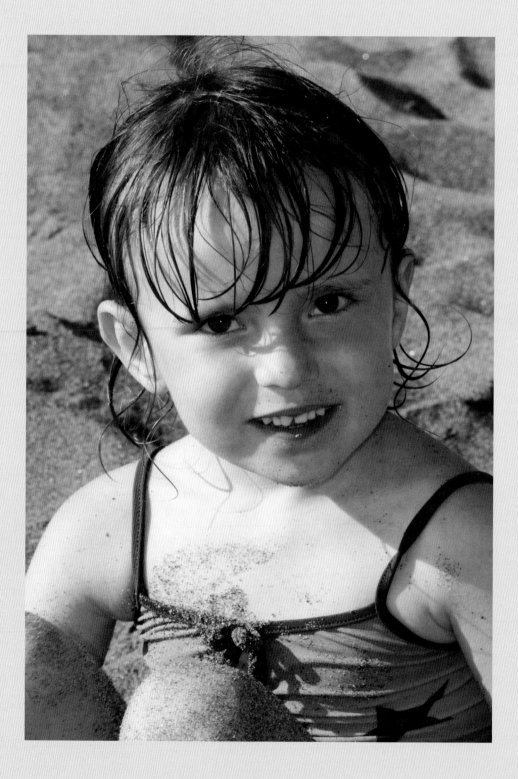

After some careful research, you've finally taken the plunge and bought a new digital camera. Once home, you quickly open the box and take out your beautiful new toy. After reading through the instruction book, you press the shutter button and take a picture—and there it is on screen. You have started on a great new adventure into the world of digital photography.

Everything happens so quickly with a digital camera: No waiting to fill the roll of film with pictures, no trip to get the film developed, and no wait for the pictures to come back. Better still, if the picture isn't what you expected, you can delete it and shoot again without wasting expensive film. With a digital camera, you learn without realizing it. Your ability to take pictures will quickly improve thanks to the instant feedback.

There's no doubt about it, a digital camera can introduce you to a fascinating world of recording images—but it's not long before the questions start: How can I achieve this…? What happens if…? Is there any way I can…? Your instruction manual rarely gives you all the answers you need.

And that's precisely where this book comes in. By talking to both beginners and experienced digital photographers about their experiences, I've put together simple-to-understand answers to many of the most frequently asked questions. This is a completely revised and updated edition that takes account of big changes in the technology over the past few years as more and more people have gone digital.

Part One of this book will help you understand how your digital camera actually records an image, and will give you a better idea of how you can make the most of your camera's controls. Part Two answers all those questions about actually taking a picture, with no-nonsense tips on how to expose and record them better. The final section tells what you need to know about transferring your pictures onto a computer, processing and improving them, printing them, and storing them.

I hope this book will take the mystery out of digital photography, that it helps to bring out the real photographer within you, and that you will gain as much enjoyment from taking and showing your photos as I do.

— **Paul Harcourt Davies**

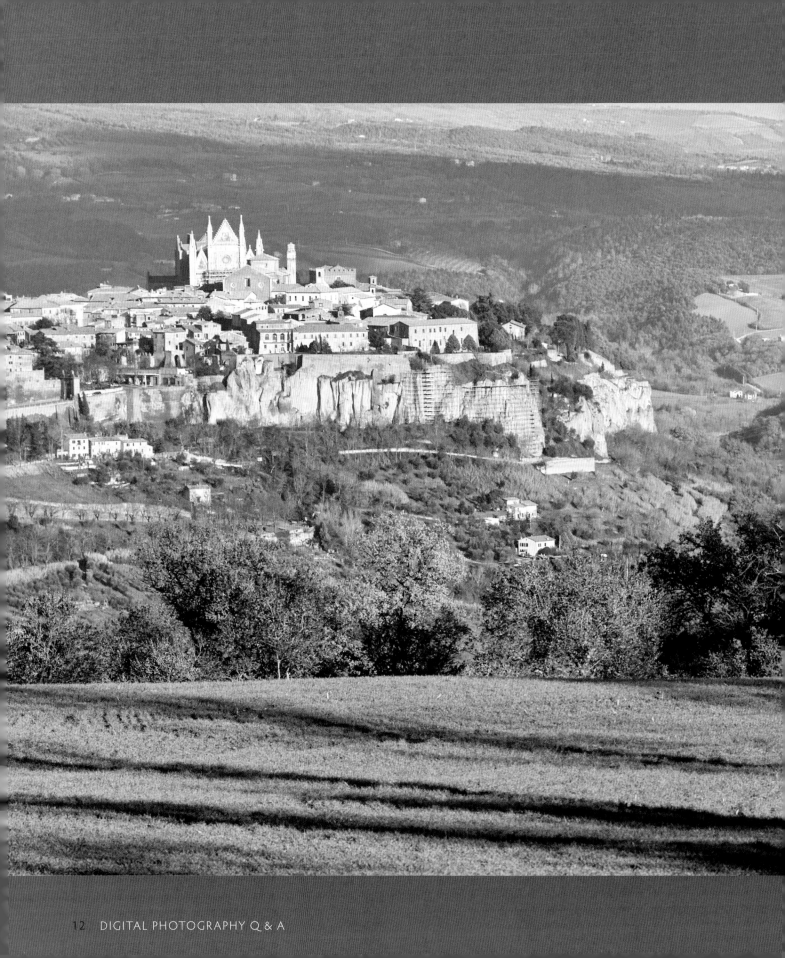

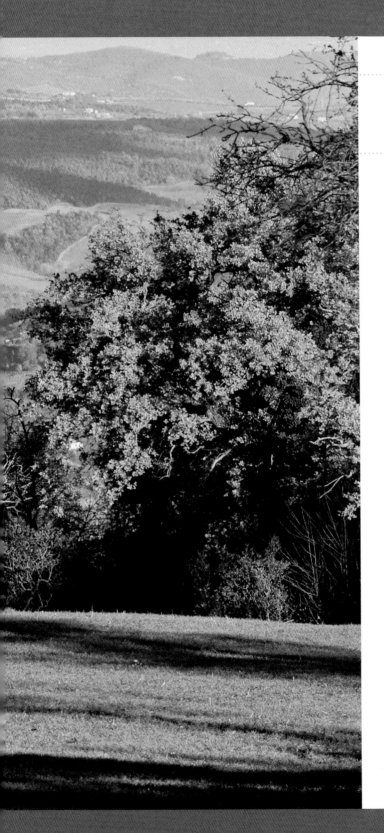

UNDERSTANDING YOUR DIGITAL CAMERA

If you're completely new to digital photography, or a little scared by new technology, it can all seem rather daunting: There's so much new jargon to learn along with a wealth of features that you may never have encountered before, even if you've been using film-based cameras for years.

This section takes you through basic concepts as well as the different features that you're likely to find on a digital camera, explaining them in a clear and simple way. If you've already bought a digital camera, Part One will help you get the best out of it. Soon you'll be getting results you never thought possible. And if you're still trying to decide what features you really need, this section will allow you to make an informed choice about what to purchase.

◄ The digital experience
Digital cameras come in all shapes, sizes, and price ranges. Choose what fits your needs best and start learning and taking as many pictures as you can.

How does a digital camera record an image?

Cameras, both film and digital, essentially are light-tight boxes. There is a lens at one end that gathers the light and focuses it on a sensitive surface at the other end, thereby reproducing an image. In the past, film provided the sensitive material. In a digital camera, the sensitive surface is a sensor, most commonly a CCD or CMOS type, that has millions of tiny photosites arranged on it in a regular pattern known as the sensor array. All cameras have some way of controlling the amount of light coming in, either through a hole (the iris) that can be set to different sizes (the aperture), or by exposing the sensor for a specified period of time controlled by the shutter speed.

On the sensor, each photosite in the array is, in effect, a tiny light meter that produces an electrical signal. The strength of the signal depends on the amount of light falling on the site. This makes it sensitive to brightness. To introduce color sensitivity, each site is covered with a red, green, or blue filter and thus responds to just one of the primary colors. In most digital cameras, these colored filters are arranged in what is called a Bayer pattern, which has two green-sensitive filters to every red or blue sensor (our eyes are most sensitive to green).

The electrical impulses from each photosite are digitized and processed by the camera to give a brightness and appropriate color that appears on screen as a "pixel." The pixels make up the image file, which is written into the camera's memory.

To get the clearest, most faithful color image on the screen, the camera software takes information from neighboring pixels and processes that, too. This is known as interpolation (see jargon buster). Things are not quite as simple as one photosite being equivalent to one pixel—although in better cameras the number of photosites and the number of pixels produced are roughly the same.

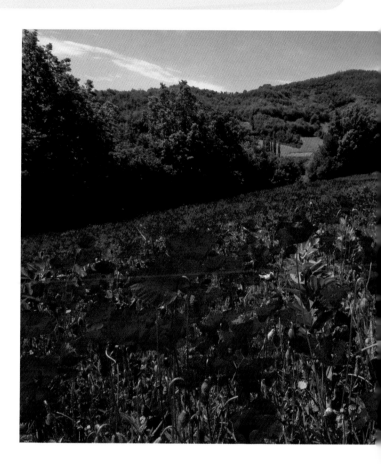

▲ Bayer pattern

In a Bayer pattern, there are twice as many green-sensitive cells as either red or blue. Color-sensitive filters in this pattern are positioned above the sensor array, allowing just one of the three primary colors to pass onto the sensor.

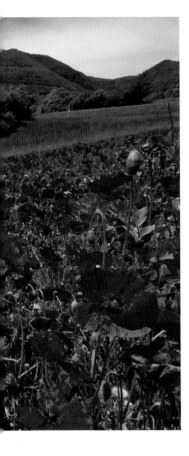

◄ Poppy field
The sensor in a digital camera records three colors (red, green, and blue)—all of which are shown here. These three colors are combined to show the full range of colors that are evident in digital photos.

▼ Filtering Color
Ideally, filters should pass only their own colors, but a degree of mixing is taken into account by the camera's software.

aperture—the hole in the lens through which the light passes, traditionally measured as a scale of f/numbers. (The bigger the number, the smaller the aperture.)

exposure—getting the right amount of light onto the sensor. Exposure is controlled by the speed of the shutter and the size of the lens aperture.

interpolation—the clever guesswork performed by the camera software for creating extra pixels by taking the brightness and color values from adjacent sensor cells.

photosite—an individual light-sensitive cell on the sensor.

pixel—a single block of information from which a digital image is made.

sensor array—the collection of light-sensitive cells that generates the pixel. The sensor array is sensitive to variations in color and brightness.

What are pixels?

ook at any magazine picture with a magnifying glass and you will see a mosaic of tiny colored dots arranged in a pattern. These are the building blocks of the image that our eyes merge into a picture. With the digital image, the "blocks" are pixels—tiny colored squares that make a continuous picture when they are packed together. You can see pixels in a digital picture when you magnify the image to a large size on your computer screen. Notice that each pixel has both color and brightness. Generally, more pixels means finer recorded detail and the ability to make larger prints (see page 46).

Strictly speaking, pixels refer to the building blocks that make up a picture—but people often use the term when they mean the photosites on a sensor, too. Each site produces information for one pixel—but the final image is created by the camera software. When you buy a camera, check the camera's specifications in its manual to find how many "effective" pixels it contains (usually given in mega— or millions—pixels: MP). This is very close to the number of photosites on the sensor, and is referred to as the sensor's resolution. Most people buying a digital camera assume (mistakenly) that more is best. Image quality will depend on a number of factors other than quantity of pixels: It is also related to the size of the photosites and how closely they are packed together, the processing used by the camera, and the optics in front of the sensor.

▲ Pixels—image building blocks
To your eye, the pixels that make up the image of this orange Hibiscus flower are smoothed out when there are enough of them (top)— but as you enlarge it (bottom), the image breaks up into blocks of color.

▲ Italian mosaic
The mosaic detail is built up of
small tiles, or tesserae, analogous
to pixels in a digital picture.

How many megapixels do I need in a camera?

A pixel is a single element of brightness that makes up a digital picture, and a megapixel (MP) is equivalent to one million pixels. We have already discussed (see page 16) that a photosite on a sensor has become an equivalent term for pixel, even though they are not technically the same thing. But even camera manufacturers refer to the resolution of a sensor in terms of pixel quantity; so we will in this discussion as well.

When digital cameras first appeared, they often contained sensors that had fewer than 100,000 pixels and generally produced jagged images that looked as if they

were made of blocks. We have now progressed to the point where even the most basic cameras (including those in mobile phones) have at least 5 – 6 million pixels, and that number is rising. The size of an image file (in megabytes, MB) is related to the number of pixels used to record it: More pixels means bigger image files. In theory, more pixels also means sharper pictures; but squashing more and more of these photosites onto the same tiny sensor does not always improve picture quality and brings other problems such as increased noise (see page 41).

To decide how many megapixels you need, think about how you are going to use the images. If you simply want to email them to friends or display your pictures on your computer monitor or a website, then you don't need a particularly large file size or high-resolution (high pixel count) images: A file compressed to a size of 1MB or less is completely adequate. However, if you want images that can serve for making good-quality, standard-sized prints, you will want larger files that must be saved at higher resolutions. And for even bigger prints, as large as 12 x 16 inches (A3; 305 x 405 mm), you will want even larger files recorded with at least an 8MP sensor or higher. You can always make files smaller without losing picture quality using image-processing software; but you have to interpolate to make files bigger, and that can lead to loss of image quality.

Also bear in mind the RAM and storage capacity of your computer, because large, high-resolution files can be slow to download and process while taking up a lot of memory. It is worth saving images on DVD to store and back them up.

◄ Orb-web spider
If you think you may want to make large prints, then set the highest resolution on your camera, as this captures the fine detail you will need. For snapshots, use medium JPEG or even small JPEG.

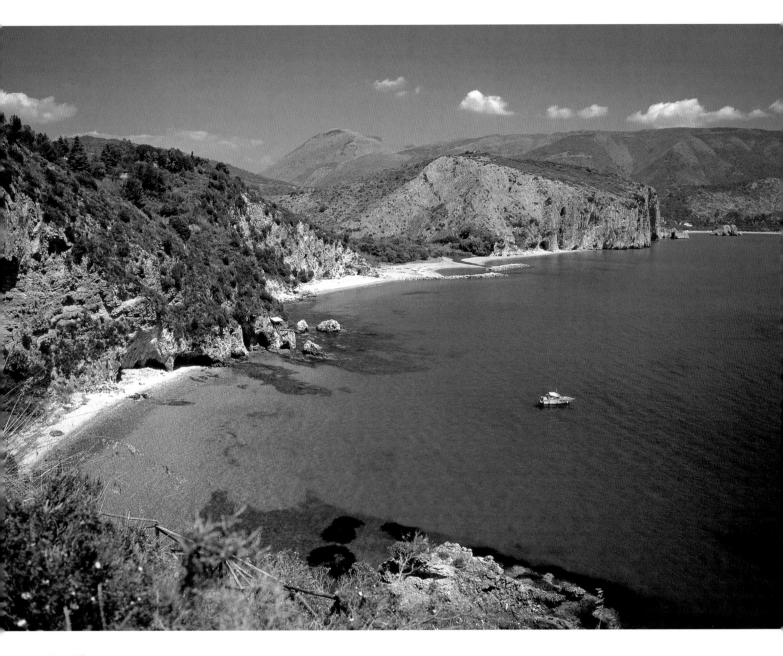

▲ The Cilento coast

Since most digital cameras allow you to change
the resolution from one picture to the next,
you can have small and large files together on
the same memory card—useful if you suddenly
come across a dramatic landscape such as this.

What does resolution mean?

The term resolution is used in several different ways in digital photography. One way, as we've learned on pages 16 and 18, refers to the maximum number of effective pixels (photosites) in a camera's sensor array. Further, you can usually select from a choice of resolutions found in your camera with which to record an image, from the maximum sensor resolution downwards.

In addition, resolution is about the detail you get in the picture. When you view an image on your computer screen, there may be no obvious difference between a low-resolution picture and a high-resolution picture.

The true difference becomes apparent when you enlarge them. Magnify the low-resolution image on screen and detail quickly breaks up as you start to see the colored blocks of the individual pixels. With high-resolution, you can reveal small details clearly as you enlarge the image to a much larger size before you reach the individual pixels. So resolution is related to file size— the bigger the file, the more information it can contain and the more pixels it will generate on screen: You capture more detail, resulting in a higher-resolution (sharper) image. Also, the larger the file size, the bigger the prints you can make with the best resolution (there's that word again—here meaning number of ink dots per inch) your printer can give you.

▲ **Low-resolution image**
With a low-resolution image, the details break up when you enlarge and the print looks a bit blurred (soft), pixilated, and perhaps grainy.

▲ **High–resolution image**
You can enlarge a high-resolution image to a much greater extent, revealing sharp details that would be blurred in low-resolution images.

What's the difference between compact, advanced compact, and SLR digital cameras?

Compact cameras, as their name suggests, do everything in a relatively small package using a single lens attached to the camera. But because of their size, they are both convenient and limited. You need a camera that is part of a more versatile system in order to cover a wide range of photographic possibilities, and you get that versatility by using a digital single-lens-reflex camera (D-SLR).

With a D-SLR, what you see through the lens is exactly what you're taking. This type of camera has a prism on top and a mirror that flips up just before the shutter opens to take the picture—a system that acts as a sort of periscope to let you see and focus with the lens. D-SLRs also have interchangeable lenses, so you can utilize many kinds of lenses from an extreme wide-angle to a long telephoto. They offer more functions than compact cameras, improving flexibility in picture-taking options, as well as the ability to progress with a camera system as your needs change.

The advanced compact type of camera offers many features found on a D-SLR, but with an attached zoom lens that usually includes a wide range of focal lengths. If you already own a film-based system, your best option might be to invest in a digital SLR body and use your existing accessories. But for many people entering the photography field or moving up from a compact camera, an advanced compact model may be a better buy than the more expensive D-SLR system.

You see a "live" electronic image on a screen in both compact and advanced compact models, whether you are viewing on the LCD monitor or through a viewfinder. Many LCD screens are high definition, making it quite easy to focus with them. Live view is also a recent introduction to D-SLRs that is becoming quite common. It enables you to use a D-SLR in odd shooting angles as well as making it easier to control them remotely with the view through the camera transmitted directly to your computer screen.

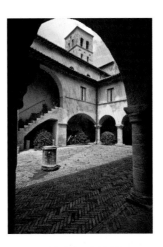

◄ **Precise framing**
With a digital SLR, what you see through the lens is precisely what you will get in the picture, which is just what you need when you want to frame shots very accurately. Current D-SLRs tend to be 10 megapixels and more, providing large files that are essential to serious photographic work.

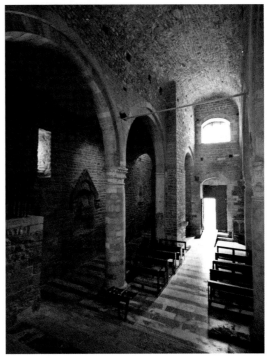

▲ **Grab shots**
You can usually use a compact digital more quickly than a D-SLR for taking photos on the spur of the moment, like capturing the "perfect light" through an old church doorway before it changes.

What are memory cards? And which ones can I use with my digital camera?

A memory card is simply a card or mini disc that you place into a slot in the digital camera. Each image that you take is stored on it until the card is full—at which point (or even before) you can transfer the images to a computer.

Most cameras are designed to use just one type of card (a few can handle more), with Secure Digital (SD) currently the most widely used. Compact Flash (CF) cards are used in many D-SLRs, though SD and Secure Digital High Capacity (SDHC) are also used in a number of D-SLRs as well as in compact and advanced compact cameras. Sony has its own system of memory cards called Memory Sticks that can only be used with Sony equipment.

Physically, CF cards are slightly larger than SD and can usually provide greater storage capacity. However, SDHC cards are now available with ever increasing memory size. CF comes in two types of cards and have a controller chip built in that allows very fast data transfer with suitable cameras: Type I cards are slimmer than type II, which are usually mechanical Microdrive memory cards, and not all SLRs will take type II.

Depending on the type of memory card used, storage capacities are currently available from 256 megabytes (MB) to 16 gigabytes (GB): Some manufacturers produce variations of the larger sized cards—the more expensive offer faster rates of data transfer.

Whatever format of memory card your camera is designed to accept, you can change to a new card in seconds. The number of pictures you can store depends not just on the capacity of the card, but also on whether they are stored as JPEG, RAW, or sometimes TIFF files. And one nice feature is that you can have a mixture of file sizes and file formats (see page 24) on the same card.

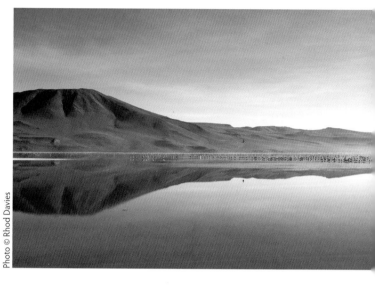

Photo © Rhod Davies

▲ Be prepared!
Prices of memory cards have plummeted, so make sure you always have spares for every picture opportunity.

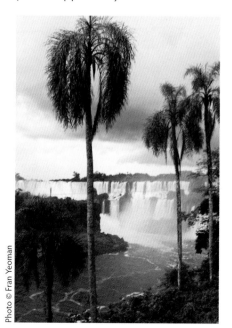

Photo © Fran Yeoman

◀ When traveling
You want to take lots of pictures when on vacation, so be sure you have enough memory card capacity to cover your entire trip.

Why do I need "film speed" (the ISO rating) with a digital camera?

The ISO rating is a term used in film-based photography to denote the film's sensitivity to light: The higher the number, the less light needed to get the correct exposure. Even though no film is used in digital cameras, and therefore the underlying mechanisms for determining sensitivity are vastly different, the same terminology has been adopted because people are familiar with the concept. The same ISO numbers are used in digital as in film—100, 200, 400, 800, and so on.

As with a film camera, you can use the ISO setting on your digital camera to make it react with more or less sensitivity to light. But, unlike film, where you have to shoot the whole roll at the same setting, you can adjust the controls from one shot to the next with digital to suit different lighting conditions.

In low-light conditions or to capture fast-moving action, set the ISO to a higher number (400 or more). On bright, sunny days or in snow, set a lower number (200 or less). If you want to be sure of capturing every bit of detail, use the lowest ISO setting for conditions. You can also adjust the brightness or darkness of the picture by using the camera's exposure compensation button.

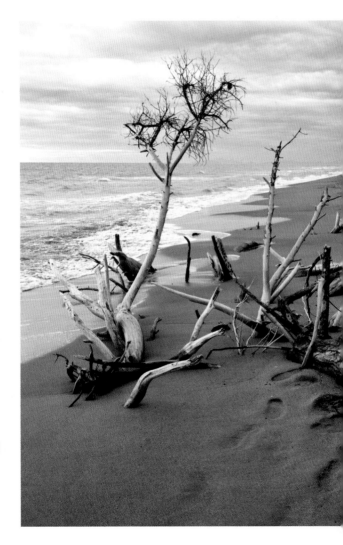

Driftwood in the morning ▶
In good light, use an ISO setting as low as possible (e.g. ISO 100) to insure optimal image quality.

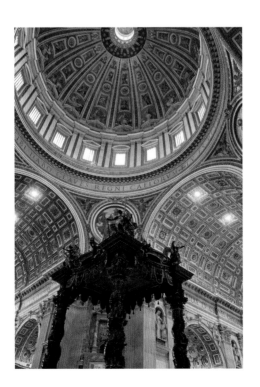

◀ Shooting indoors
Your eyes adjust to low light in interiors, but cameras need a bit of help. Set the ISO to a higher speed if you don't mind shots that can look grainy, thanks to noise (see page 41). However, I usually try to keep a low ISO and use a tripod, or at least hold the camera against a wall or on the back of a bench—anything to reduce camera shake at low shutter speed.

What are file formats and what do acronyms like RAW, JPEG, TIFF, and DNG mean?

Digital images are recorded and stored in different forms known as file formats that have evolved because the images can be used for different purposes. It takes a lot of memory to store data, so some formats compress the images in order to fit more pictures on a memory card or in your computer. Cameras can often record using more than one file format. Despite which formats your camera uses, you can usually convert to any of the others described here when working with an image-processing program in the computer.

The RAW format is usually found only on digital SLR's and more advanced compact digital cameras. RAW files are large—they include all the data from the sensor and consequently take up a lot of space on your camera's memory card and on your computer's hard drive. In addition, these files are proprietary to camera manufacturers (and, in fact, to each model they produce—except for a RAW format called DNG). That means the specifications for RAW files recorded using a Canon camera are different than those recorded by a Nikon, all of which are different than those recorded by a Sony, Olympus, or cameras from other companies. You need a software program known as a RAW converter to read these files in your computer. However, once that is done, you can convert them to TIFFs or JPEGs for display or to make prints.

JPEG is a universally readable image-file format that can display up to 16.7 million colors, the number needed for photo-realistic pictures. You can usually set the camera to a number of different resolutions for JPEG. This format uses "lossy" compression, which means that data is discarded every time you open and re–save a file. To get around this, download JPEGs into your computer and open as a duplicate when using your image-processing program; that way, you can go back to the original image if anything goes wrong.

Guanaco ▶
To store more photos on your memory card and still retain good quality images, set your camera to shoot JPEGs at a medium compression level.

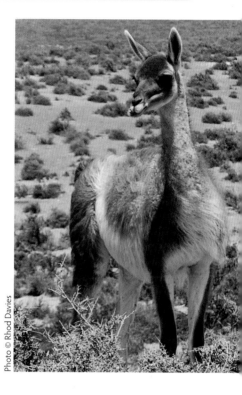

Photo © Rhod Davies

TIFFs also handle 16.7 million colors, and do so without the data loss found in JPEGs (but TIFFs consequently take up a lot more memory). Not all cameras use TIFF for recording, and in practice you see little, if any, difference between large, low-compression (fine quality) JPEG files and TIFF files (but you can fit six or seven times more JPEGs on a memory card).

DNG is a universal RAW format (meaning non-proprietary) introduced by Adobe® (who supplies a free, regularly updated converter for all RAW formats as a download). Most major camera manufacturers still prefer their own versions of RAW, but DNG is an excellent option, especially if you use multiple cameras. Since it is a RAW format, no data is lost in conversion, and it functions seamlessly with all Adobe imaging products while still allowing you to embed the original RAW file, so that is not lost to you either.

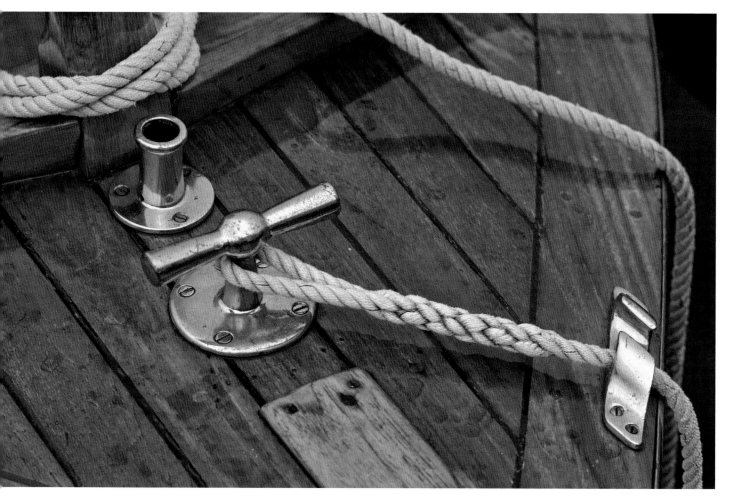

▲ All hands on deck . . .
Large, fine quality JPEGs retain detail. You don't have to shoot RAW format or TIFF to record excellent pictures.

jargon buster

You'll probably never need to know what the abbreviations stand for, but to impress your friends here they are!

JPEG—Joint Photographic Experts Group

TIFF—Tagged Image File

RAW—a pure data file

DNG—Digital Negative (a RAW format)

I notice several different metering modes—which one should I use?

All digital cameras have a light meter built into them that reads the light level in a scene and assesses the combination of shutter speed and aperture required to get the "right" result. Provided nothing in the scene is very light or very dark, a camera's internal meter works wonderfully.

Problems may arise, however, when there are bright lights that create highlights or reflections, or the sun is in the scene. At the other end of the brightness scale, dark shadows or low light may also pose a challenge. In situations such as these, the meter can be fooled. If you include too much bright snow from the scene, for example, the meter may determine that the whole scene is bright; consequently it tries to underexpose, and the result is too dark. Conversely, take a photograph in a shady wood and the camera tries to overexpose because this time there is not enough light.

Camera designers have been ingenious in finding techniques to deal with these issues. They have provided metering modes, a solution where the camera doesn't measure light equally from across the scene. The different modes are described in the jargon buster.

However, it is an advantage with a digital camera to record a photo and look at the LCD screen to see if the result is too light or too dark. Take the picture again using the exposure compensation button: If it is too dark on screen, increase the exposure (go to the plus (+) side); if it's too light, decrease exposure (move to the minus (–) side).

jargon buster

center-weighted mode—the meter sensor takes most of the reading from the center of a scene.

spot metering mode—takes a reading from a small area: You choose the part that is a midtone, take an exposure, and apply the exposure lock control to use this value for the whole scene. With practice, this is very accurate.

matrix metering—sometimes called evaluative metering, this is much harder to fool and is the most reliable method in a great majority of situations. The viewfinder is divided into a number of different segments and the meter sensor reads light from each one (the more segments it has, the less likely it is to be fooled). The readings are compared with combinations programmed into the camera's memory. Most scenes can be accurately evaluated, apart from impossibly bright highlights or the proverbial black cat in a coal cellar.

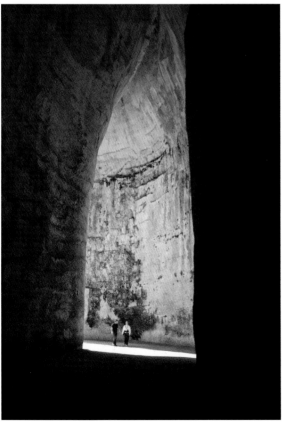

▲ Photographing snow
Snow can be tricky whatever metering mode you set. However, a good plan is to use Matrix metering mode, look at the result on your LCD screen, and then either lighten or darken the shot using the plus (+) or minus (–) signs on the exposure compensation control.

◄ Scenes with large dark areas
When there are dark areas in a picture, the meter can be fooled, leading to a photo that is overexposed. Use minus exposure compensation and repeat the shot. Or try Spot metering if that is an option: Point at an area in the scene that is not too dark nor too light and lock that exposure by pressing the shutter release half way down and hold while you then recompose.

My camera has a number of different exposure mode settings. What are the differences between them?

Camera manufacturers try to make things easier for us. In automatic exposure mode (AUTO), the camera selects a combination of shutter speed and lens aperture that the designers think is the optimum for a particular situation. Often there are also extra automatic modes that are designed for specific situations (signified by appropriate icons), where the camera will select the settings for scenes such as landscapes, close-ups, sports/action, portraits, and even snow scenes or fireworks. These often work well.

But as you get better at taking pictures, you may find that you want to make some of your own choices using other exposure modes. With Program mode, the camera still selects the f/stop and shutter speed combination, but you can often shift one or the other of those settings to your needs. The camera will then adjust to maintain an equivalent exposure value.

You can also gain more control with Aperture-priority or Shutter-priority modes. With Aperture-priority you set the aperture and the camera sets the shutter speed to provide the correct exposure—a smaller aperture means that more of the image is in sharp focus (useful for close ups). With Shutter-priority you set the shutter speed and the camera adjusts the lens aperture—useful when you need a high shutter speed to freeze a fast-moving subject.

If you want total exposure control, set your camera to Manual mode if it has that setting. You then have to take an exposure reading and set the shutter speed (see page 58) and aperture (f/number) to the values you want (see page 59). This is great if you are an experienced photographer, but it's much easier to go automatic if you find the manual adjustments a little too complex.

Wasps at home ▶
AUTO is useful when you want to shoot immediately because you don't want to take the time to make camera settings (like recording these wasps before they become disturbed!). However, you do surrender control over things like depth of field and motion, which may be a worthwhile price for getting a shot you might otherwise miss entirely.

◀ Bush cricket close-up
Aperture-priority is helpful when you get close because it maximizes sharpness through the photo, allowing you to capture the greatest amount of detail.

My camera has a wide-angle and a telephoto setting. What do these do?

Nearly all popular digital SLRs have interchangeable lenses, allowing you to alter how much you can fit into the frame without changing your position. Compact digital cameras have only one fixed lens—but nearly all have settings allowing you to create the effect of interchangeable lenses. A wide-angle setting captures an expanse of the scene and is great for landscapes, while the telephoto setting lets you close in on details.

Zoom lenses give the best of all worlds, since you can stay in the same position and alter the framing until the image looks the way you want it. For zoom with digital compact cameras, check the specifications so that you are familiar with the different angles of view that the lens can give. And don't forget to experiment to see the effect yourself.

Some compact cameras create the effect of wide-angle or telephoto digitally (rather than optically by using the lens) by cropping a portion of the picture and filling the image area of the crop by interpolating. However the image may not be sharp due to the effects of the interpolation (see page 15).

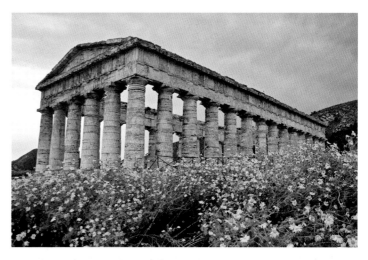

▲ Ancient Greek temple in Sicily
For effective wide-angle shots, include something in the foreground, such as these wild chrysanthemums that lead the viewer's eye into the shot.

◄ Backlit leaves
Telephoto settings and lenses are essential for picking out details such as these leaves. Keep your subject large in the frame for extra impact.

◄ St. Peters, Rome
Although the shot looks as if it was taken on a wide-angle setting, it was shot from some distance away using the telephoto setting— useful when you cannot get closer.

What's the difference between an optical zoom and a digital zoom?

If you've had a film camera with a zoom lens, then you'll be familiar with optical zoom, which operates by moving lens elements inside the body tube to shift from a wide-angle to a telephoto view. A digital zoom does not involve the lens; the camera's electronics look at a central, smaller portion of the scene to give a telephoto view. This narrowed angle of view is a digital crop that captures less detail than optical zoom, causing a loss of quality—particularly if you then make a big print of the image.

▲ **Religious parade**
Digital zoom is useful provided your subject is not too far away and you don't need to make a large print.

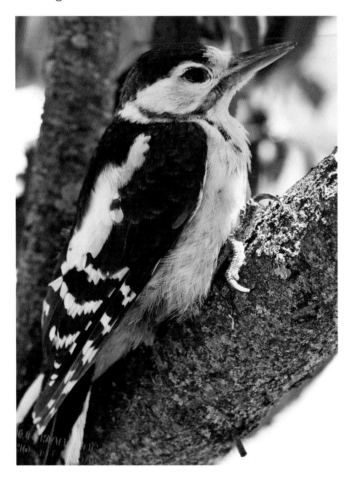

◄ **Young woodpecker**
Here, the optical zoom was used to get close to the bird and create a high quality, detailed image suitable for making a large print.

What are different focal-length lenses used for?

When used on a 35mm film SLR, a standard lens with a focal length of 50mm gives approximately the same coverage as the human eye. Likewise, wide-angle lenses range from 35mm through even shorter focal lengths, such as 28mm, 24mm, and 20mm, with coverage becoming progressively wider. These are useful for landscapes and for shooting within confined spaces.

On the other hand, a modest telephoto lens, such as 100mm, mounted on a 35mm film camera is great for portraits. And a telephoto or zoom lens with a focal length of 200mm or greater will help you close in on distant subjects.

However, when you use these focal lengths on a digital camera, the effect appears magnified unless you have a "full frame" D-SLR (which are quite expensive cameras), where the sensor size is the same as the traditional 35mm film area (see page 35). The angle of view is different on digital cameras where the image area of the sensor is smaller than that on a 35mm film frame. You therefore will need to make adjustments to compensate for this different angle of view.

Which lens to choose? ▶
A vantage from a tower in the city of Noto, Sicily, offered the chance to capture shots of the Baroque architecture. A wide zoom setting allowed the pan-oramic shot (far right), while a medium telephoto focal length was useful to create a composition showing the front of the cathedral (near right).

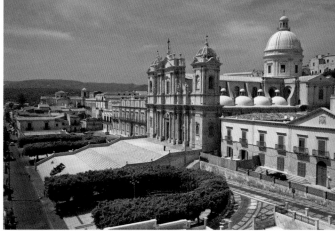

Filing the frame ▶
Zooming from a wide-angle focal length to a moderately telephoto one lets you emphasize more details in a scene.

My digital camera has several flash modes. What are the differences between them?

Many cameras come complete with a built-in flash, but control is limited, so the lighting is not always as subtle as you might like. Various flash modes are offered on most cameras, though not all cameras have all these selections. Terminology may differ somewhat among the hundreds of camera models on the market, but these are the general meanings:

◄ **Indoors**
The Auto flash mode generally fires automatically when there is not enough light for a correctly exposed picture, enhancing photos indoors.

Auto flash mode—This may function in several different ways depending on the type of camera you have (compact, advanced compact, D-SLR). In general, the built-in flash will automatically fire in low-light or backlit situations.

Flash off—A selection that makes sure the flash does not fire. This is handy when a venue, such as a concert or perhaps a museum, prohibits flash and you don't want to fire accidentally.

Red-eye reduction mode—This is designed to eliminate the red color that often appears in the eyes of people (in animals this is often green-eye). A brief flash is produced before the main flash fires, causing the pupils in the eyes of your subject to constrict (provided they are looking at the camera). Now less light from the primary flash is reflected by the subject's retinas (which is what creates the red-eye).

Fill flash mode—The flash is forced to fire under any lighting condition, even full outdoor sunshine. It is used to put some light into dark areas, especially shadows on faces, and it can add punch to colors.

▲ Close-up subjects
Built-in flash can give good
coverage with close-ups (as
long as the flash is not too
close) and lights up subjects
in shade.

Fill flash ▶
Fill flash is useful outdoors
for adding a little extra
punch to the colors when
subjects are in shade and
might otherwise appear dull.

Many cameras have shutters that are basically two separate curtains that move across the sensor (or frame) with a space between them (the width of the space determines shutter speed). These cameras may offer other flash modes based on this:

Front-curtain sync mode—This is normally the default, with flash firing as soon as the first shutter curtain opens across the total frame.

Rear-curtain sync mode—Also called Second-curtain sync, this is when the flash fires just before the second shutter curtain closes, which can result in light trails behind moving objects being registered realistically.

Slow sync mode—In Slow sync, the shutter is kept open long enough to allow the exposure of ambient light (daylight or artificial light) along with the flash, avoiding those dark areas in the background that you usually find when using just a small flash.

The metering system for on-camera flash often only works over a small range of apertures and distances. If you use it for close-ups, you will get overexposure at wide apertures. Use apertures of f/8, f/11, or smaller to prevent this. Check the LCD screen after making your exposures. If your shots are too dark, repeat using a wider aperture; if they are too light, stop down before reshooting.

The built-in flash on the camera seems very small. Can I use a separate, more powerful flash?

Your camera's built-in flash can work wonders in small-sized rooms and by lighting people who are close, but don't expect it to illuminate the interior of a large building or the background in a shot of a large group (for backgrounds use Slow sync mode; see page 33). If you want to use a separate flash with a compact camera, then choose a camera that allows you to turn off the built-in flash and has a mount on top called a hot shoe (nearly all D-SLRs have a hot shoe).

The external flash unit can be used either directly on the camera via its hot shoe or by using a connecting cable to place the flash off-camera. Flash exposure for external units is handled through several possible modes set on the flash.

Digital TTL—Through the Lens (TTL), this mode functions where the flash unit and camera are dedicated (they are designed specifically to communicate electronically with each other). Here the camera measures and controls the light that reflects from the scene through the lens, quenching or cutting off the flash output when the scene is exposed correctly.

Auto flash mode—The flash unit has its own photocell to control output according to light reflected from the subject. This mode can be used with non-dedicated camera and flash. It can get the job done, but does not generally expose as accurately as Digital TTL.

Manual flash mode—The flash provides output while exposure is controlled by setting the correct Aperture/ISO combination depending on distance from the subject. You can sometimes adjust output to a fraction of maximum. Manual flash mode often requires a bit of experimentation (reviewing test photos on the camera's LCD) and experience to get proper illumination.

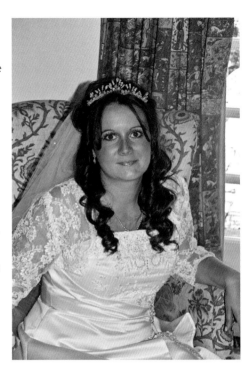

The bride ▶
My daughter asked me to take her wedding pictures, an honor (and responsibility) I could not refuse. Here I combined light from a window with light from a flash held away from the camera to brighten shadows.

▼ Fritillary caterpillar
TTL metering of flash is a great help with a D-SLR when you are faced with close-up subjects. Small apertures are needed to capture every fine detail, and a flash gives you enough light without using a slow shutter speed.

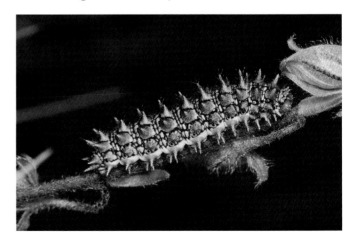

Can I use my 35mm film camera lenses on my new D-SLR body—and what is a "crop factor?"

Many people bought digital SLR bodies as a way of upgrading after having invested in a collection of lenses for a film-based SLR system. Some manufacturers are better than others in allowing "backwards compatibility" (the capacity for the D-SLR to utilize lenses originally manufactured for film cameras); others have introduced new functions and new lens mounts. You can often use older lenses, but this usually means you cannot utilize some or all of the exposure metering modes, and focus has to be manually set. It may be possible to attach your film-camera lens, but be aware of the differences in angle of view and use them to your advantage where possible.

The sensor array in a digital camera that does not have a full size sensor is smaller than a frame of 35mm film. Therefore, the sensor does not capture the full image delivered by a film-camera lens, but only a cropped portion. Lenses therefore appear to have different focal lengths on film and digital. Though the lens' focal length does not actually change, the image looks as if you have increased the focal length to move in closer.

This effect is often described as a focal length magnification factor, or crop factor. For example, when a focal length of 24mm is used on a digital camera with a crop factor of 1.5, the image appears as though a 36mm lens were being used on a 35mm film camera (24 multiplied by 1.5, thereby reducing coverage). A landscape photographer would need to use a 16mm lens on a digital camera to get the equivalent view of a 24mm focal length on a 35mm film SLR.

However, since a digital camera uses the central part of the image, lens designers do not have to worry about correcting curvature of the lines at the edge of the frame, and have produced a marvelous new generation of extremely wide-angle lenses (though you might have to budget in order to afford one of the new wide-angle digital zooms).

For photographers using long telephotos, the effect of the crop factor works to their advantage. A 200mm lens, for example, effectively becomes a 300mm lens with the same maximum aperture. All this is great for wildlife photographers because now macro lenses capture bigger images on digital, and because telephoto lenses get you much closer to your quarry.

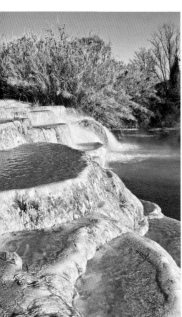

◄ Hot springs
Focal lengths of lenses appear longer on most D-SLRs than on 35mm film cameras because the sensor is smaller than a frame of film. Here a 16mm wide-angle lens was needed to give the same coverage as a 24mm film lens.

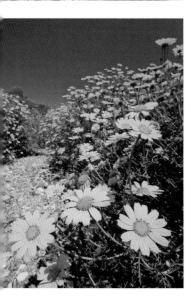

◄ Wild Chrysanthemums
Digital cameras with less than a full-sized sensor (smaller than a 35mm film frame) have posed new opportunities for lens designers. I often use ultra wide lenses, such as this 10 – 20mm zoom, at close quarters since they let you capture the subject in the context of its background.

What is the purpose of using a tripod with a digital camera? How and when should I use it?

Tripods are used to prevent blurred images that can often result when your hands move slightly as you take a picture (everybody's hands shake to some small degree or other when holding a camera). When the shutter speed is fast enough, then slight movement makes no difference. You could increase the ISO setting to allow use of higher shutter speeds, but high ISO makes digital noise more likely (see page 41). A tripod is the ideal solution when you want detailed pictures, such as inside shots, where light levels are low.

In the base of most cameras is a threaded connection that lets you screw the camera onto a tripod head. It's a standard screw thread used on all tripods and cameras. If you are going to use a tripod regularly, then it might be worth attaching a "quick mount" to the bottom of your camera that lets you connect and disconnect from the tripod quickly. Even though a rigid tripod can be heavy and is an extra item to carry, it is best to avoid cheaper, lightweight versions that may topple over or not hold a camera steady.

The next best option is a monopod. These have a single extendable leg and support a camera—your

▲ **Blurring from camera shake**
You are forced to use longer shutter speeds in low-light conditions, making even slight camera movement more evident than at faster shutter speeds.

▲ **Reducing blur**
A tripod will reduce blurring due to camera shake. Supporting a camera on a table or against the wall is sometimes a useful alternative to a tripod.

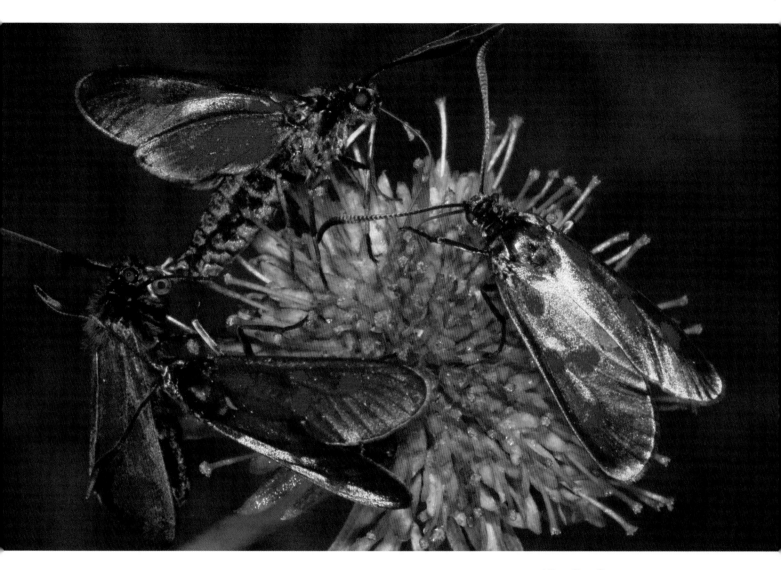

▲ Feeding frenzy

Increased magnification makes any movement more apparent, whether it comes from camera shake or the slightest breeze moving the subject. Minimize the risk of a blurred image by mounting the camera on a tripod and even erecting a windshield around your subject. Finally, make the exposure using the self-timer, as even your hands on the shutter button can create vibration.

legs provide the other two supports of the "tripod." With a little ingenuity, you can easily find other ways of supporting the camera. Brace your elbows (or the camera itself) against an available wall, column, chair back, or table. If you want to shoot from a low viewpoint, crouch in a kneeling position or lie prone using your elbows as support. Alternatively, cradling a soft camera bag between your knees produces a camera support that absorbs vibration. A good buy if you use a telephoto focal length is a small beanbag. It molds itself around the camera and gives surprisingly sturdy support.

What does the white balance control do?

This control, often abbreviated as WB, makes sure that white objects in your scene come out looking white in your photo. Though that might seem obvious, it is important to realize that different light sources have different color temperatures, so that objects illuminated by them have differing color casts. Household light bulbs, for example, have a greater proportion of red and yellow than sunlight, so photos taken indoors often have a red or yellow tinge to them, while fluorescent lamps give a greenish cast. Even the sun in the early morning illuminates objects differently than it does at noon.

With film-based cameras you needed to change the film or use filters to suit the light source. With a digital camera, you can alter the white balance control. Many people set the white balance to Auto, which works reasonably well even when scenes contain several different light sources. Most digital cameras also have different settings for light sources to correspond with Sun, Cloud, Shade, Incandescent, and Fluorescent. The program in the camera adjusts the levels of blue and red depending on which light source you have set.

Advanced digital cameras often let you customize the white balance setting through their menu system, allowing your camera to measure the actual color temperature of the existing light. The selection is usually called Custom or Manual white balance. The method consists of pointing the camera at a gray card (a standard photographic tool that reflects 18% of the light) and making an exposure. The camera then registers that shot's white balance as its default until you change it.

With the same scene you can create a variety of different effects by changing white balance:

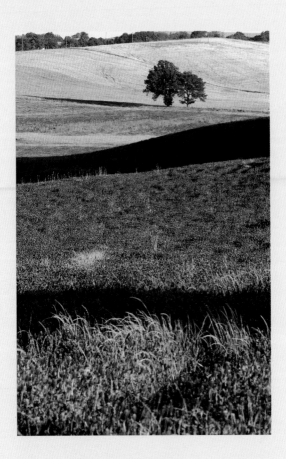

▲ Auto white balance setting
Most cameras provide a pretty good assessment of the color temperature of the light, electronically tweaking the red and blue responses of the camera sensor to get the right balance.

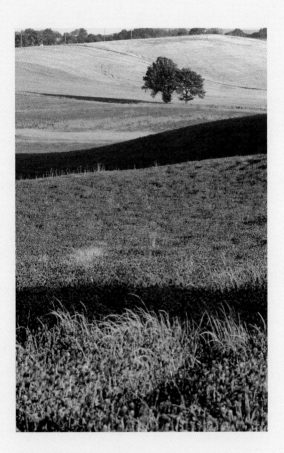

▲ **Shade setting**
Adjust the white balance to Shade, even in bright sunlight, to produce a warm feel, as the light looks when the sun is low in the afternoon sky.

▲ **Incandescent setting**
Incandescent lamps with a hot filament produce more red and yellow than sunlight produces, so the Incandescent white balance setting neutralizes that with an increased blue response. If you are outdoors and set the white balance to Incandescent, the greater amount of blue gives the photo a decidedly cool appearance.

▲ **Fluorescent setting**
With the white balance set to Fluorescent, a digital camera cuts down the extra green by adding magenta.

I used to use filters on my film camera. Can I use them with a digital SLR?

Many film-camera photographers make use of filters, often screwing them on the lens to make colors appear warmer on dull days (warm-up filters), accentuate blue skies or cut reflections (polarizing filters), or to reduce contrast between the sky and ground in a landscape (graduated filters).

It is certainly possible to use these filters with a digital camera, but it is much simpler to adjust the white balance (see page 38) to warm or cool the color in a scene.

Morning and evening light have a good deal of yellow (appearing warm), whereas the harsh light of the sun high in the sky is bluer. The white balance settings electronically adjust the proportion of blue to red so that you see colors that look as you remember them, whether the pictures are from different times of day, taken on cloudy days, in the shade, or even under street lights.

Effects filters that create starbursts, tobacco-colored sunsets, and a host of other things in film cameras can be imitated with great results using digital technology and the inexhaustible supply of tricks and effects that you can apply to your pictures when they are in your computer.

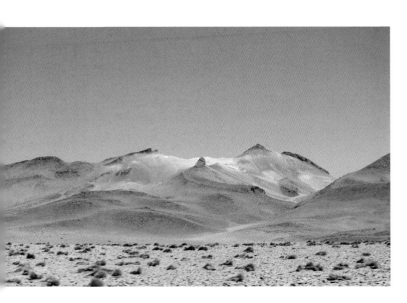

▲ Deepening blue skies
A polarizing filter works great on D-SLRs for deepening blue skies (and also cutting reflections from water, glass, or other shiny surfaces).

▲ Warming up colors
The use of a warm-up filter (which is slightly orange in color) makes things look as if they're taken in late afternoon or evening. Setting your digital camera's white balance to Shade creates the same effect.

What is digital noise?

The background hiss that you hear when turning up the volume of a sound system where no CD is playing is called noise, and it comes from random movements of tiny electric charges in the electronic circuitry. In a digital camera, this electronic noise creates pixels of various colors that are not related to the image.

The effect is more obvious in less sophisticated cameras, but even some top-notch D-SLRs have been criticized for the noise they create. It is most obvious when you increase the ISO setting or open the shutter for a relatively long time, making the camera more sensitive when light is low.

Think of the data that makes up your picture as being in two parts—the information that you want from the scene, and random contributions from inside the camera. When the camera operates at a low ISO setting, the proportion of noise to information from the scene is small. But the more sensitive the camera setting, the higher becomes the proportion of noise-to-scene information.

As you progressively enlarge images, this noise becomes more obvious and you see odd colors and artifacts—additional information generated by the camera that bears no relation to the image. And the noise becomes even more apparent when you try to sharpen using a filter in your image-processing program, such as USM (unsharp mask).

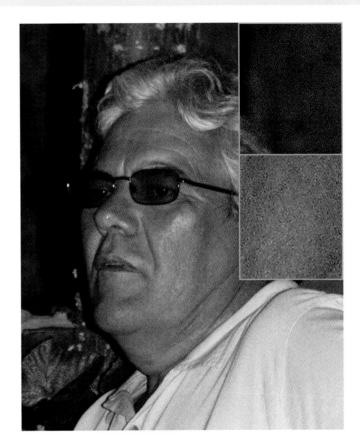

▲ **Digital noise**
Noise appears as colored speckles within the picture. It is most often generated at high ISO settings or when a slow shutter speed is used. This example shows magnified portions of the background and the man's face, both of which are "noisy."

Reduce noise by using the lowest ISO setting you can and try not to use long exposure times.

My digital camera seems to use up batteries very quickly. Is there anyway I can reduce consumption?

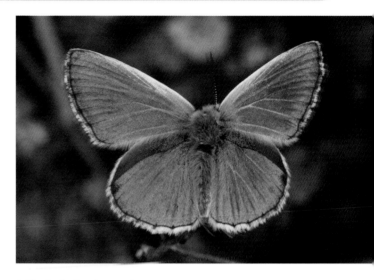

Digital cameras are high-drain devices: Their batteries must light an LCD display, power an internal computer, move motors in a zoom lens, and even recharge a built-in flash. Usually low-priced alkaline batteries can't handle such a power drain for very long.

In the long run you might be best served by buying a couple of sets of rechargeable NiCad (nickel cadmium) or NiMH (Nickel metal hydride) cells (if there is a size available for your camera), keeping a spare set fully charged in your camera bag. These types don't run out gradually, but keep the same voltage and then die. Unlike alkaline batteries, NiCad batteries can be recharged—but it's best not to recharge them until they have completely rundown, since the cells have a "memory" and will not recharge fully the next time unless they are drained. NiMH batteries are slightly more expensive, but don't have the memory problem.

Some cameras only run on highly expensive lithium batteries. If you want to take lots of pictures, make sure you choose a model that gives you the rechargeable option, too. It's kinder both to your pocketbook and to the environment.

▲ **Flash drains batteries**
The drawback of digital cameras is their dependence on battery power. Using flash as fill light to capture butterflies and other subjects drains batteries rapidly, so always keep a spare set fully charged.

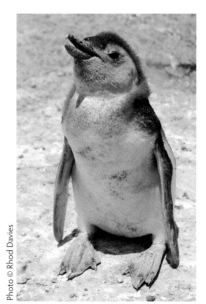

Photo © Rhod Davies

◄ **Cold conditions**
Your batteries run down more quickly than normal in cold conditions. You can keep the camera warm in a bag or pocket when it is not in use.

top tip

To conserve energy, try to avoid switching the camera on too often to look at images. Download them and look at them on a computer instead.

I am thinking of upgrading to a D-SLR. Is it very different than a film SLR or my compact?

The external look and feel of a digital SLR is currently very similar to a film SLR—but inside, instead of a motor drive and film-transport mechanism, the D-SLR houses a sensor and associated electronics.

The factor that feels somewhat overwhelming at first is the number of functions you can control through a system of menus, dials, and buttons. It is essential to sit down and experiment (or play, as the case may be) with these controls as you read through the camera's instruction manual (or the Magic Lantern Guide for your particular model). There is often a quick-start tutorial to get you up and running. Explore the rest of the capabilities as you need them.

On the back of all D-SLRs is a series of buttons and dials that allows you to access images and control camera settings such as ISO, metering, white balance, exposure compensation, and others. Your images are available immediately for playback review on the LCD screen, which is a great advantage over a film camera because you can reshoot the picture on the spot if you are not satisfied with the original exposure. And there is no need to change film or add filters when you're working under different lighting conditions, another advantage of digital.

Many cameras also allow you to make color or contrast adjustments. In practice it is better to do this at a later stage using image-processing software in the computer. For one thing, when you change settings on the camera, it is all too easy to forget that you have done so and leave those settings on as you move to other shooting conditions. If you used filters on a film camera to cope with different types of light and times of day, then a digital SLR lets you do this through the white balance control.

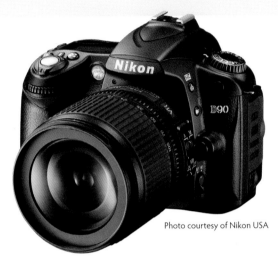

Photo courtesy of Nikon USA

▲ Digital SLR

At present, the general look, layout, and feel of the digital SLR and the film camera are basically the same, since the design is well established. But technology always advances, and D-SLRs may start to incorporate unique design aspects in the future.

The versatility of D-SLRs ►

D-SLRs are versatile and offer the opportunity to make outstanding pictures whether you are shooting landscapes, portrait, action, or other types of photos. They offer expanded exposure control in difficult lighting situations and are great for close-ups such as this, as you can frame your shot accurately, see the results immediately, and re-shoot if the focusing or exposure isn't quite right.

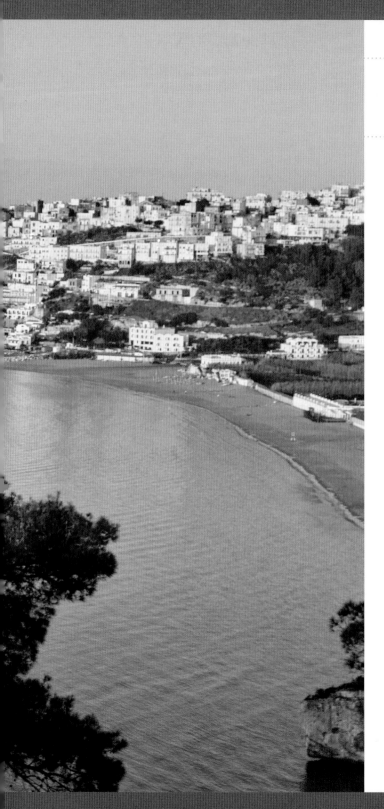

Part Two

TAKING DIGITAL PICTURES

If you're completely new to digital photography, or even a little frightened by new technology, it can all seem rather daunting to begin with. There is so much incomprehensible jargon to come to grips with, and options that you may never have encountered before, even if you've been using film-based cameras for years. This section takes you through the different features that you're likely find on a digital camera and explains clearly and simply what they can do. It will help you make an informed choice about what to purchase or, if you've already bought a digital camera, it will help you to get the best out of it.

◄ The seeing eye
Create striking pictures by choosing your viewpoint carefully and using existing features such as trees, rocks, or a shoreline to help with composition. Good digital photography relies as much on your ability to see the potential of the scene as on your technical skill.

What resolution should I set on the camera—and can I change it from picture to picture?

The resolution relates to the number of photosites (pixels) used to record the image. Compression aside, more pixels means a larger file size, and a bigger file size means more detail. Low-resolution files save space on your memory card, and are fine for small prints or for uploading your files for placement onto the web because they transfer quickly. However, if you're going to produce large prints, then you need to use the largest file size your camera offers (RAW or the JPEG combination of highest resolution/least compression; a few D-SLRS also record TIFFs). You can always reduce a file's size later to make a smaller print or use as an email attachment, but you can't make a higher quality file by adding information. Many photographers record high resolution (especially as RAW files) and decide the use later—you never know how until you see the result.

With a digital camera, you can change the resolution for each picture you take. So if you see something you think might make a great print, take it at as high a resolution as your camera will allow.

See the table below for a summary of how many pictures you can store on a memory card at different resolutions.

APPROX. NUMBER OF PHOTOS (12MP CAMERA)

Memory Card Size	JPEG Low Res/Hi Compression	JPEG Hi Res/Low Compression	RAW
512MB	570	115	30
1GB	1140	230	60
2GB	2280	460	120
4GB	4560	920	240
8GB	9120	1840	480

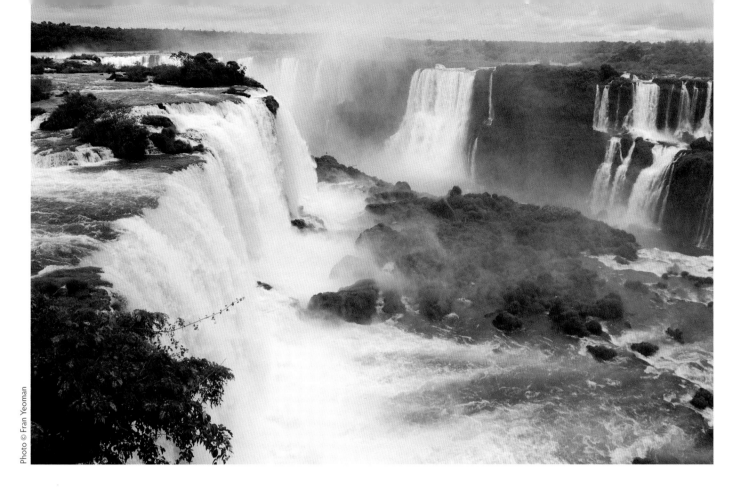

▲ Photographing the sights

If you find yourself starting to run out of space on your memory card while traveling, you can switch to record JPEGs at lower resolution and/or higher compression to fit more photos on the card.

◄ Capturing details

To capture as much detail as you can, set the camera's JPEG resolution as large as possible and the compression as little as possible (fine), or record using RAW format if your camera offers that option.

Is there any point in shooting RAW?

JPEGs rule for many digital photographers because this format offers several benefits: The files are already processed to a large degree before downloading to the computer, you can print them, and they are universally accepted, meaning you can send them to nearly any computer in the world. However, some image data is lost through compression when a JPEG is processed in the camera, especially if you shoot low-resolution files.

A RAW file contains all the information captured by the camera's sensor with little or no processing in the camera, so there is no loss of data. On the other hand, RAW requires more processing using software in the computer to create a finished image because there are a number of adjustments that can be made to enhance the recorded file.

As mentioned earlier (see page 24), every camera manufacturer—even each individual camera model—uses a different version of RAW. This variety might work for now, but what of the future when the technology may no longer support specific past formats? Adobe has attempted to address this dilemma by creating Digital Negative (DNG), a RAW format designed as an open standard and publicly available. DNG files can be adjusted and enhanced in Adobe's image-processing programs, including Lightroom® and more recent versions of Photoshop® and Photoshop® Elements, as well as in some other RAW processing programs.

Whatever RAW format you use can be handled by Adobe's raw converter, Photoshop® Camera Raw, a program that is regularly updated and available as a free plug-in download for the Adobe programs mentioned above. There are also a number of third-party programs

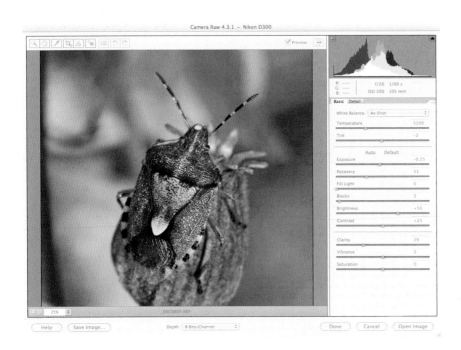

◄ **RAW interface**
A RAW file can be opened using Photoshop Camera Raw (pictured), a plug-in found in Elements and Photoshop, or one of several other RAW converters that are available. These programs have the ability to alter a number of the photo's attributes, such as white balance, exposure, contrast, hue and saturation, and sharpening, among others.

that are created to convert RAW files (Aperture™, Capture One®, Bibble, SilkyPix®, and LightZone™, among others).

Import the RAW files from your camera or memory card into the RAW conversion/processing program on your computer. These programs permit you to modify and tweak many attributes of the image, such as color temperature, exposure, contrast, color hue and saturation, sharpening, and so on. The auto, or default, settings work well for many purposes. When you are done making your adjustments to the RAW file, export it to your standard image-processing program for further fine-tuning and save it as a JPEG or TIFF. The original is left unaltered, like a negative or transparency that you preserve and archive. Advances have occurred in RAW converters over the past couple of years, as in every other aspect of digital photography, so you will probably be able to refine even more from a RAW file in the future.

It may seem there are a large number of steps in the RAW development process, but you get used to a regime for enhancing these image files. The term "workflow" refers to all the different actions you take to create a final image, from shooting the photo, to processing in the computer, exporting and saving, and keeping your files organized within your image catalog. The efficiency of newer programs such as Lightroom means you can import RAW files, display them, quickly process with sliders, caption multiple images, and retrieve them when needed by keywords. Workflow becomes less of a chore and allows more time to be out taking more pictures.

◄ RAW seed heads
RAW format is rapidly becoming the format of choice for serious photographers. Using it, you retain all the detail that the camera can record and then have great freedom to control nuances of color without changing your original files.

How big should I make a file when taking a picture?

With the advent in the past couple years of memory cards that can store 4GB of data and more, file size is not the concern it used to be. The size of an image generally corresponds to resolution, with more pixels creating larger files. The exact size of the image file being recorded depends on a number of factors, including the file format used, the model of camera, whether compression is being applied by the camera's processor (quality), and even what is in the scene (a clear sky records less data than a finely detailed close-up).

The size of file you require is largely governed by what you want to do with it. Small file sizes of 250 – 750 kilobytes (KB) are all you need if you're going to look at your pictures only on a computer screen (approximately 72 pixels per inch—ppi). A sensor of any size will produce files that can be emailed; in fact, you will often need to downsize and/or compress them in your image-processing program.

If you want to make prints, then you need bigger files to give the finer detail, approximately 2 – 3 megabytes (MB) for 3 x 5 inches (7.6 x 12.7 cm at 240 ppi—a sensor size of 3 – 5MP or more); and approximately 12 – 20MB for 8 x 10 inches (20.3 x 25.4 cm at 240 ppi–a sensor size of 8MP or larger). If you set your sights on getting work published in books or magazines, or on producing printed publicity brochures, then you will need to supply files as large as 25 – 50MB at a resolution of 300 ppi to give the best detail. When in doubt, stay with larger file sizes since they offer you a wider choice of potential uses.

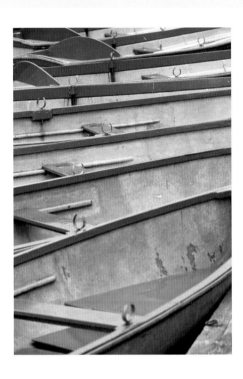

◄ Large print
If you want to produce a large print, say 8 x 10 inches (20.3 x 25.4 cm) on your inkjet printer, then you will need a file of approximately 12MB.

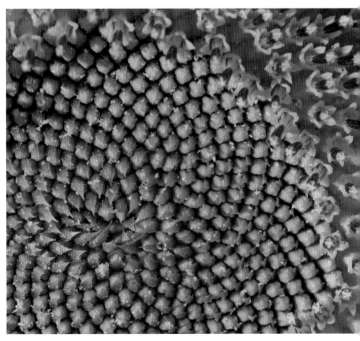

Sunflower ►
If you think a shot may make a good print, use the highest resolution that your camera can provide. This will give you a large file size with the most detail possible and offer the most latitude for cropping photos.

How much of the frame should my subject fill?

Shooting something large enough to fill the frame makes a huge difference in your prints. They will be sharper if you don't need to eliminate portions of the image by cropping during image processing on your computer. Enlarging to print what is left of the original image can result in loss of quality and detail. From a compositional point of view, filling the frame as much as possible makes your subject more important in the picture and also eliminates extraneous detail, resulting in a tighter composition. Conversely, if you set individuals or even groups of people in a huge expanse of beach or fields, they look small and insignificant in the frame.

Of course, how you choose to compose the image is a personal decision and will depend on the effect you wish to achieve. But always avoid taking pictures against a background that is too cluttered. Moving in close will help exclude messy or distracting elements—but too close might overdo it since a bit of background can become an effective frame for portraits, for instance.

You may create a dramatic picture by sometimes moving so close that you "overfill" the frame, eliminating all border and background detail. Photographs of nature subjects, patterned material, and textures such as wood and stone, for example, all become abstract when they fill the frame, and can make great screensavers.

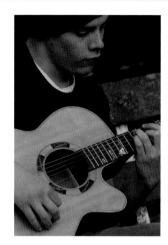

◄ Guitarist
To show an activity, get close enough to show the person and what they are doing within the frame

▼ Penguin choir
Though closing in will add emphasis, capturing some background gives context to a picture and tells you more about the subject, such as where these penguins live. With digital, you don't have to decide whether to close in or stay back—take as many different shots as you want and choose the best.

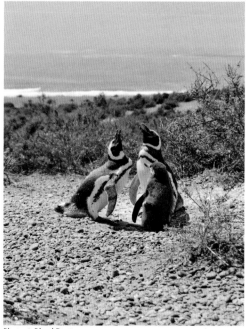

Old gramophones ►
Often the shape and color of the subject lets you decide to go for maximum impact by framing to eliminate extraneous portions of the scene.

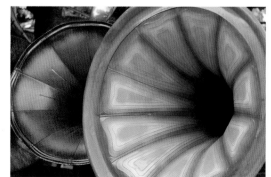

Photo © Fran Yeoman

Photo © Rhod Davies

When should I shoot horizontal pictures or shoot vertical pictures?

Holding your camera in the standard position produces a horizontal shot (with the longest part along the width of the frame) that has traditionally been called the landscape format or orientation because it is well suited for that type of scenic photo. Turning the camera 90°, so that the long side of the frame is vertical (tall), produces what is know as the portrait format (this makes sense, since faces are longer than they are wide, especially when you include head and shoulders). But photography "rules" are made for breaking: You can use a landscape format for people shots, and vice versa. The timing of when to do so will depend on your subject matter. Check the composition in your viewfinder or on the LCD and decide which format fits best.

Subject shape ▶
When you are deciding whether to opt for a portrait or a landscape format, be guided by the shape of your subject. Often subjects that are taller than they are wide work better as a portrait format, while landscape format suits wider subjects—but break the rules and see what happens!

As a general guide, if your subject is wide, the landscape format is best. On the other hand, if you are photographing a subject that is tall, a tree or a tower for example, then portrait format will be more suitable. Groups of people lend themselves to a landscape orientation. If you have a panorama setting with a very wide frame, you could try turning the camera vertically for dramatic pictures. The examples given on these two pages show you the range of effects that can be achieved with different subjects.

◀ Horizontal format for groups of people
The horizontal format usually works best when there are more than two people in the frame. Move in as close as you can while still getting all of the shot that you want.

Photo © Kevin Kopp

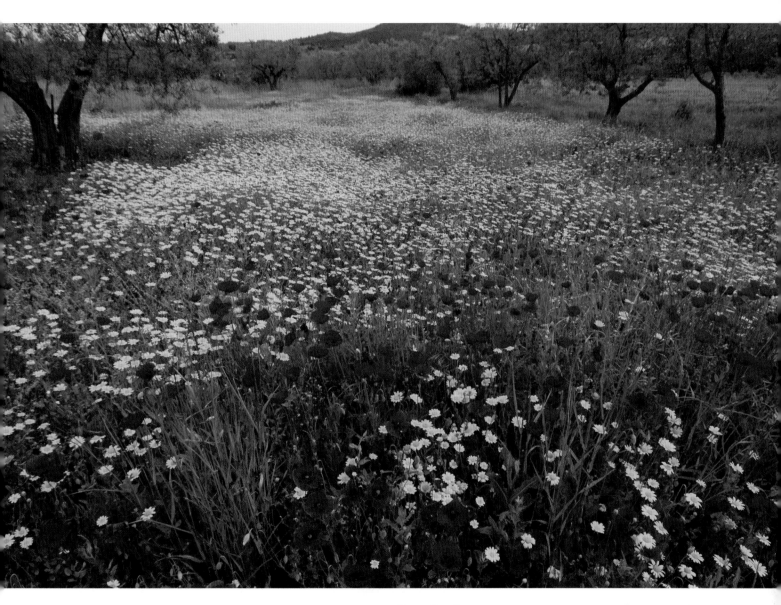

▲ Leading lines

Regardless of whether you are shooting a vertical or horizontal picture, try to lead the eye into the frame. Fences, paths, buildings, and the edges of a field—as in this shot—can all help you do this.

Where is the best place to position the subject in a frame?

Successful photography often means grabbing attention and leading the eye to the point of interest. Classical painters understood this and used rivers, fences, rows of trees, or fields of waving corn as devices to pull your gaze into the picture so that your eye instinctively follows them. You can include such devices when choosing where to position your subject in the frame. Things that are arranged diagonally in the frame, such as grass stems, fences, and branches, give a sense of movement, even if the objects themselves are stationary. These are the little things that make your pictures stand out. You can use an overhanging branch, an archway, or even a shadow to frame your subject, too, so that attention is drawn to it.

The most obvious place to put your subject is dead center in the frame—the bull's-eye shot. But surprisingly, placing the subject slightly off center creates a better feel to the photo. In fact, it is often desirable to go one step further: Don't just offset the subject to one side of the center, but also do the same up or down. This compositional effect is based on the "rule of thirds" (see diagram below), where the view is divided by imaginary lines that run vertically and horizontally across the image to create a grid. Placing your subject at the intersections of the lines creates a more pleasing composition, although the placement doesn't have to be exactly on the intersection to create the right effect.

▲ The "rule of thirds"
The yellow circles on the diagram show the strongest points at which to position your subject in a composition.

Sunset, portrait format ▶
In landscapes, you need to balance the sky and the land. To emphasize the sky, position the horizon about one third of the way up the frame; and to emphasize the land, the sky area should end about one third of the way down. Avoid placing the horizon across the center, as this cuts the image in two.

▼ Poppy off center
Experiment! If it seems obvious that a flower center should be in the middle of the frame, try placing it slightly to one side instead. In fact, do both and decide later which you prefer.

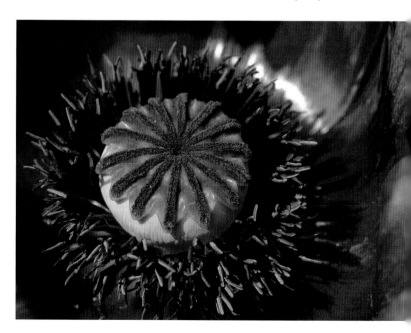

My camera's LCD screen sometimes appears too dark or too light. How can I control this?

When exposed correctly, your pictures should appear as bright or as dark on the camera's LCD as they do when properly displayed on your computer screen, meaning you can effectively use your LCD as a sort of visual exposure meter. If, however, all your scenes appear too light or too dark on the LCD, then you may need to re-set the LCD screen through the camera controls. Among the various menu options in your camera is usually one that lets you adjust the screen brightness. Place yourself in the kind of lighting in which you would normally view the LCD screen and make small changes in the screen brightness, adjusting through trial and error and comparing the image on the LCD screen with those that have been downloaded.

top tip

The LCD screen on your camera is very difficult to see if the sun is shining on it—so shade it with your hand or use a commercial screen shade.

The menu ▶
You can usually adjust the brightness of the LCD in the camera's menu system.

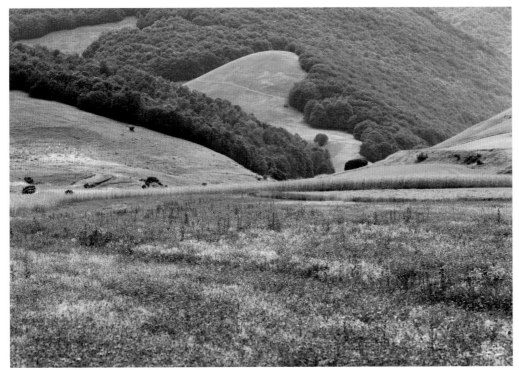

◀ Screen brightness
It is important to have the brightness of your camera's LCD screen properly adjusted. If it is not, you might think all your photos are incorrectly exposed, leading you to reshoot a number of images. Look from time to time to see that your camera's LCD is displaying pictures at about the same brightness as they appear on your computer screen.

Sometimes my digital camera does not get the right exposure balance—for example, between a white dress and a dark suit at a wedding. How can I correct this?

Both film and digital cameras can have difficulty handling the tonal difference between a very bright and a very dark object in the same frame (known as dynamic range). Setting most digital cameras on AUTO exposure mode, where the sensor analyzes the scene and calculates the brightness, works well in a number of circumstances. However, if you have very bright or very dark objects in the frame, the exposure meter tries to make the bright or dark things a tone of average gray, so you get under or overexposed shots, respectively.

For example, if a bride is wearing a white dress, the camera's exposure meter reads a large amount of light, determining this to be a bright scene. AUTO mode adjusts to compensate for the brightness, resulting in a grayish dress and dark faces. Similarly, when reading large dark areas, the meter will decide more exposure is needed, and any light subjects present in the frame will become burned out (overexposed).

But don't give up—the strategy is to compromise. The great thing about digital is that you can review the

▲ Graduation day

Exposure is often a compromise in shots of people because it is necessary to get the skin tones right. Skin tones that are slightly too dark looked tanned and may be acceptable, but bleached out skin that is too pale is not.

◄ High-contrast scenes

In a scene that has both light and dark areas, it makes a difference where you point the camera. If you point at bright subjects, the dark areas will become too dark; if you point at light subjects, the highlights get burned out. Check the LCD brightness setting regularly to make sure the screen is accurately portraying scene brightness.

photo on the spot and take it again making changes to exposure if needed. And, provided all the information is in the digital file you have recorded, you can also make changes later using image-processing software when you notice image areas on the computer screen that can be improved.

On cameras that offer the option to select from several metering modes, matrix (evaluative) metering takes readings from several segments in the viewfinder, so there is less risk of the meter being fooled (see page 26). If your shots still come out too dark, increase the exposure time: If they are too light, decrease it. You can also use the exposure compensation button (+/-) and adjust until the picture on the LCD looks right to you. Most cameras let you adjust at intervals on a plus and minus scale. To make things brighter, go to the plus side; to darken things, go the other way.

When I take landscape photos using the AUTO exposure setting, either the land is exposed properly but the sky looks too bright, or the sky is right and the land looks dark. What's the solution?

This is the landscape version of the wedding dress problem (see page 56). In a landscape with a bright sky and darker land, the exposure meter takes the middle route and you may lose highlight and shadow details. There are some ways around this, enabling you to capture enough information to make further adjustments later on your computer. It is easier to lighten a dark landscape than it is to darken a burned out sky.

If you want to capture a dramatic sky, then tilt the camera so that the ground occupies a smaller proportion of the frame. To take an exposure reading for the land, make sure the sky occupies a small part of the frame. You can then increase or decrease the exposure via the compensation button to get a better result.

If you want to expose both sky and land as accurately as possible, and you have a fairly straight horizon, then you can use a gray graduated filter. Move the filter until the gray portion is over the sky—this brings exposure times for land and sky into the same ballpark. This sort of technique works better on cameras where you can see exactly what you're getting through the lens; otherwise it is guesswork.

▲ Tricky exposures

To avoid the risk of the camera's built-in meter interpreting the whole scene as very dark, and therefore compensating by overexposing the shot, take a meter reading from a midtone, such as the interiors of the gondolas. Then lock the exposure by pressing the shutter button half way down. This technique will retain detail in both the bright sky and the dark sides of the gondolas.

Photo © Rhod Davies

◄ Shooting a bright scene

The contrast between the dark-skinned seals and the light rocks and sky has the potential to create metering problems. Take a picture and look at your results. Repeat the shot with plus compensation if the seals are too dark (because of the bright rocks). Alternatively, use minus compensation if the rocks or sky look burned out.

How do I make my picture look sharp?

The impression of sharpness is helped by getting a few things right. First, you have to focus the camera carefully. With autofocus, the most basic cameras focus on the center of the picture, which means a subject that is placed off-center might not be sharp if it is at a different distance from the camera than the center focus point. In this situation, it helps to use a smaller aperture (a bigger f/number, see page 59) to get more of the foreground and background in focus—known as depth of field.

If the picture lacks sharpness overall, then you might have camera shake. Use a higher shutter speed, a tripod, or some other support (see page 36).

Good lighting is also a key ingredient to making things look sharp, and one that is often forgotten. Pictures made in dull light hardly ever look sharp even if, technically, they are. Lighting things slightly from the side creates small shadows that make things look sharper; using a flash off camera helps, too (see page 34).

▲ Cleopatra butterfly
When photographing butterflies or other flying insects, choose your shooting angle so that the camera back is roughly parallel to the wings and body to ensure the entire insect is in sharp focus.

▼ Close-up mode
When the camera's close-up mode is set, the lens aperture is automatically selected to give increased depth of field. The shutter speed drops and you may need to use a flash or tripod to avoid camera shake.

Slow shutter speed ►
In this shot, the shower-head is sharp, but at 1/15 second, the shutter speed is slow enough to blur the water and keep a sense of movement. A faster speed would have frozen the water drops.

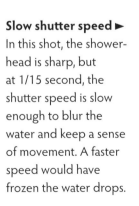

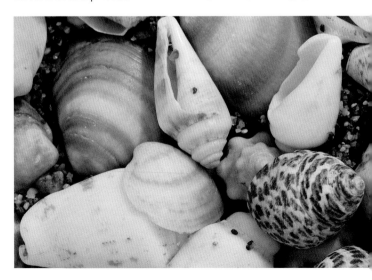

How do I control which portion of my picture is sharp?

To control sharpness in this way you have to understand depth of field—how much area in front of and behind an in-focus subject appears sharp. You can alter that range by varying the size of the lens aperture. To increase the area that appears sharp, so that objects both relatively close to the camera and far away are all in focus, set a high f/number (f/8 or higher, decreasing the size of the lens opening). This increases the depth of field. Conversely, set a low f/number (f/4 or lower, increasing the size of the lens opening) to focus on a subject that is close to the camera so that it stands out against a blurred background, creating a shallow depth of field.

When you move in for close-up photos, it is technically impossible to get everything in focus. You have to select which parts of the scene or subject you want to be sharp. When there is an animal (or human) in a shot, focus on the eyes. If they are sharp, your brain forgives other things that are out of focus. With a dog that has a long muzzle, you will find that eyes and nose tip can not both be in focus, so take your shots slightly from the side. This has the effect of reducing the effective distance between them from your camera's viewpoint and you can get them both sharp.

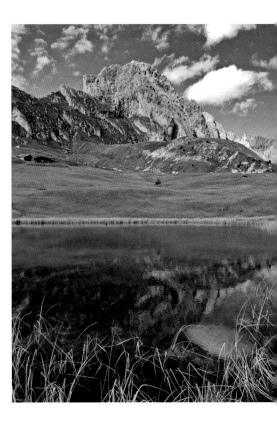

Sharp alpine landscape ▶
Everything from the grass in the foreground to the faraway mountains and clouds is crisp in this springtime landscape, a result of using a narrow aperture (f/11), which gives you a long depth of field.

◄ Artistic blur
Use a wide aperture setting to create shots where the foreground is sharp and the background is blurred. This focuses attention on your intended subject. It works most effectively with the telephoto settings on your camera's zoom lens—the longer the focal length, the more the background appears out of focus.

How do I blur just the background in my digital pictures?

This is related to the previous question, and there are two ways of doing this. The first can be accomplished by applying your photographic skills to set your camera properly. The second way is to manipulate the image on the computer later.

With portraits or shots of flowers and birds, a soft background makes the foreground appear much sharper and adds impact your pictures. The basic photographic technique is to use a shallow depth of field, where the subject is in sharp focus and anything behind it falls off quickly into a blur. Use the widest aperture you can on the lens—try something from f/2.8 to f/5.6, for example. Panning is another technique that creates a blurred background (see page 61). And, of course, if you have movement in the scene, use a slow shutter speed to show motion blur (see page 58).

The background blur effect is also more pronounced if you isolate your subject with a telephoto setting on your zoom or with a telephoto lens. Wide-angle lenses take in a bigger field of view and appear to offer much more depth; yet if your subject is the same size in the viewfinder, the depth of field is the same at a particular aperture, whatever lens you decide to use.

You can create a blurred background in an image-processing program. First select the subject and then invert to select the background. Work on this using the Filters menu: You can apply a Gaussian blur or one of the other appropriate filters available.

◄ **Useful blur**
The blurred background helps accentuate the head of this wheat. A wide aperture of f/2.8 was used to isolate the subject against the field behind it.

◄ **The fun of the fair**
A fast shutter speed will freeze movement—but use a slow speed (e.g. 1/8 second) and a moving subject is blurred in a way that suggests action.

What is panning and how do I do it?

Panning means moving the camera horizontally to follow a quickly moving subject to keep it at the same point in the frame. It is another way to record a relatively sharp subject against a blurred background.

You may wonder what the point of panning is when you can use a fast shutter speed to freeze a moving subject. But that also freezes the background. On the other hand, panning gives a sense of movement to a shot. By not using a fast shutter speed, the stationary background blurs while the moving subject comes out sharp as the camera pans to follow it.

▼ Rainy day driving
Panning takes practice, so don't be discouraged if your pictures aren't quite want you expect the first few times you try this technique. Panning produced interesting patterns behind this car as it drove past on a slick day.

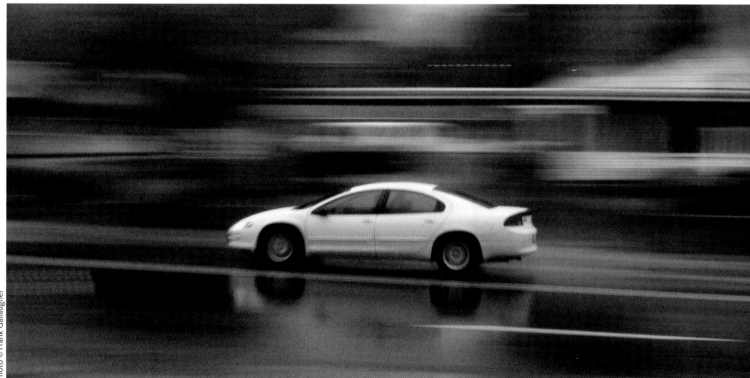

Photo © Frank Gallaugher

Can I take a number of pictures in quick succession with my digital camera?

Many digital cameras have the capability to shoot pictures in rapid sequence. To do so, the camera must have a buffer, which is an internal memory to temporarily store image data before it is written to the memory card. Check a camera's specifications before buying to see if it has a function for continuous shooting and a burst rate—the number of frames it can record per second (fps).

Some professional-level cameras have a maximum buffer capacity of up to 100 pictures and a burst rate of 8 fps. This will vary depending on whether you are shooting RAW files or JPEGs, and with the resolution and quality if recording JPEGs. Continuous shooting is great for sports and action photography, and can come in handy when trying to capture the perfect expression in a portrait. Don't worry about shooting too many images in a burst—you can always keep photos that work and delete those that don't.

jargon buster

continuous shooting—a drive or shooting mode that allows the camera to record a quantity of images in rapid succession as the shutter release is held down.

burst rate—the number of frames shot per second (fps).

buffer—secondary memory where images are held before being compressed and recorded to the memory card.

Dog at play ▶

If you have a camera that allows continuous shooting, your picture will change from one frame to the next as your subject moves. Timing is everything— you have no idea which frame will appeal most until you view the sequence.

Photos © Kevin Kopp

Do I need a D-SLR to take photos at sports events—or can I use a compact camera with a built-in zoom?

You can have a lot of fun at sporting events with a compact camera, but you will probably have to move around the periphery of the playing field to anticipate critical moments or wait for the action to come to you. A typical 7 – 10 megapixel compact camera might have a built-in zoom that provides the equivalent of a 35 – 140mm lens on a film camera, giving a modest wide-angle to short telephoto range.

If shooting JPEGs, set the highest resolution and best quality available. You can then usually crop to close in on the action and still have an image file big enough to make an acceptable print. You are, in effect, creating your own digital zoom on the computer.

However, nothing less than a D-SLR will do if you want to emulate professional sports photographers. It offers a number of advantages beyond the capability to use very long focal length lenses, including generally higher resolution for larger crops, more exposure options for tricky lighting situations, and continuous shooting with faster burst rates. However, the weight and length of some telephoto lenses means you may have to use a monopod or tripod, and obtain permission from some venues for using this equipment.

◄ **Pre-focus on the critical action**
With fast-moving sports action you need to pre-focus and allow plenty of space to the left and right to be sure of getting the subject in the frame. The camera here was also panned (see page 61), so the background looks slightly blurred, creating a sense of movement.

How can I increase my chances to capture split-second action?

Luck sometimes plays a part in photographing that perfect moment where you freeze the action, but you can maximize your chances in one of two ways. First, shoot a series of pictures, perhaps several bursts in continuous shooting mode (see page 62), because you never know precisely where in a cycle of events the special picture will present itself. A number of D-SLRs models can shoot a whole series of photos fast enough to let you choose the perfect shot later.

Second, it pays to know your subject. The best animal photos, for example, are taken by people who study their subjects for a long time before they set out to take pictures. Similarly with sports shots, the best photographers understand the sport so well that they can, to a large extent, anticipate what is going to happen next and be ready.

Start by thinking about the kind of picture you want to take: Visualize it and put yourself in the best position possible to capture it. Take care of all the photographic variables before lining up the shot: Place the right lens on the camera, select an appropriate shutter speed and aperture, set continuous shooting mode if available, and have autofocus ready—you might want to use predictive autofocus for moving subjects if you have that option. In this way, all you have to do is press the shutter and maybe move the camera slightly to change the framing. If you leave yourself with too much to do at the last minute, you may fumble with the camera and lose that perfect opportunity.

Back safely—barely ▶

To anticipate the moment, you need to understand what you are photographing, be it a pick-off move at a sporting event such as baseball, or perhaps the way a particular bird or animal behaves when you are photographing wildlife. Action changes from one moment to the next, so it helps greatly to have a camera that recovers fast enough to let you take shots in rapid succession. The fastest burst rates are usually found on higher-level (and therefore more expensive) D-SLRs.

Photo © Kevin Kopp

How do I set the camera to include myself in the photo, too?

Putting yourself in the picture involves using the timer on the camera, which is usually set with an option found in the camera's menu system. Often there is a choice of setting a delay of two or ten seconds between the time you press the shutter release and the time the shutter actually fires. Some advanced cameras also offer the capability to shoot using a remote control.

You will want to secure the camera on a support, such as a tripod, so that you can set it up and then get yourself into the frame. Don't make the composition too tight so you have enough leeway if you don't manage to get into exactly the right position. You can always crop the picture later. Also make sure the camera's timer delay is long enough before the shutter releases to let you get into the frame without rushing.

There is nothing quite like a blinking light on the camera as the countdown takes place to generate fits of giggles. This can sometimes work to your advantage, however, and give you very happy-looking shots. The chances are that you will need several attempts because someone will always be looking away from the camera, yawning, grimacing, etc. But the great advantage of a digital camera is that you can review each shot until you get one that you're happy with.

Wedding party ▶
Getting yourself into a group shot may take several tries—first the laughter and then the helpful comments. I placed a camera on a tripod and set the timer before running to join this giant wedding party.

I see people hold the digital camera away from their eyes or even above their heads to get pictures. Any hints on making this work well?

The LCD on a point-and-shoot digital camera is larger than a viewfinder and usually lets you see what you're pointing at more easily, so you don't always have to hold the camera up to your eye. This allows you more versatility in positioning the camera when taking pictures. You might be able to find a vantage point—steps, balconies, etc.—that lets you look down on something without intruding or placing yourself in a precarious posture of leaning too far. But there is still an element of guesswork with a digital camera held high. Your best bet is to take a shot at the wide end of the zoom range, so that the subject is still somewhere in the frame if you point too high or too low. One advantage is that you can quickly take a shot, check it on screen, and make any adjustments. Also, if the final shot is tilted, you can always straighten it later on the computer.

Always take a few shots to give yourself more chances to capture the moment with passing celebrities, the band in a parade, or the lead singer of a rock group as he launches into the crowd. Start shooting a little before you think the best shot will occur and, if necessary, take a number of shots in quick succession.

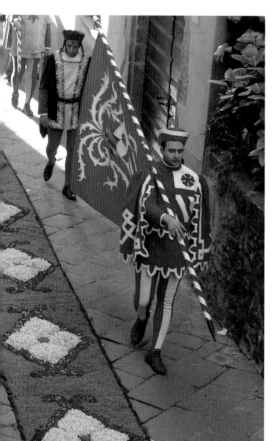

◄ Everyone loves a parade
Often the best view of parades and crowds is from above. Here a convenient window looked down on the scene below, but the camera had to be held way out to capture the action and avoid the heads of people below.

Time to talk ►
Getting too close would have broken the spell. Here I was able to hold my camera out while standing on a balcony without intruding to capture two old friends as they sort out the world's problems. Of course, a telephoto lens also helps me be discreet in this situation.

I often get dark backgrounds when I photograph people or groups indoors. How can I avoid this?

Dark backgrounds occur when a flash unit is powerful enough to light only things in the foreground—not easy to avoid when you use a small flash such as the one built into your camera. You could use the Slow sync mode if your camera has one (see page 33), where the shutter speed is slow and captures background light. Or you could also invest in a more powerful external flash unit if you think you will use it often enough (see page 34).

Alternatively, you can easily adjust the sensitivity (ISO setting) of a digital camera. Set it higher than you would outdoors so that you can make use of the ambient light inside. This way you can use the flash as the main light source and also get enough light in the background to prevent it from looking black.

◄ Deliberately dark background
Sometimes a dark background can actually enhance a shot. Here it allows the baby, nestling in the crook of her godmother's arm, to stand out from the background. Check the picture on the LCD display to see if you're happy with the result.

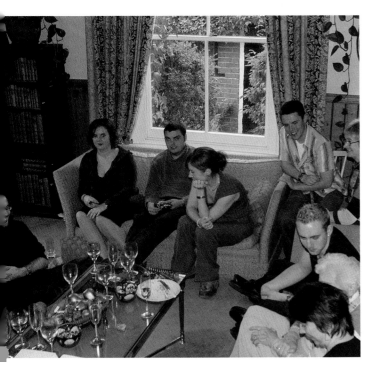

If your camera has a Manual exposure mode, you can first frame your shot without the flash and move the settings for aperture and shutter speed until the meter indicates correct exposure, making note of the selected settings. Then readjust the aperture to be a stop or two narrower than indicated so the flash gives the main light (your camera controls its exposure) and you also pick up ambient light. Check the LCD, readjust, and re-shoot as necessary. And remember, light from the flash (close to daylight in character) and indoor lights have different color temperatures. If your camera's white balance is on Auto, it gives a compromise—usually on the warm side, which works well with people.

◄ Slow sync
For this shot, I used the Slow sync mode on my camera's built-in flash. This left the shutter open after the main burst of flash had fired, allowing light from the window to illuminate the background of the scene.

What sort of arrangement works best if I want to photograph a group at a wedding, party, or some other event?

Professional photographers make group photography look deceptively easy, but it's not as simple as it looks. They must impose their personality on ill-disciplined, raucous, outgoing elements (if your friends are like mine!). Be prepared to be a master at dealing with people when photographing a group!

If you are at a wedding, look for an opportunity. Often the professional will set up the group, take the shots, and then let guests have a chance, too. Watch for the moment just after the picture is taken when people start to relax.

If you set up a group yourself, two traditional arrangements work well. In one you can place the tallest people in the center, descending in height towards the outside of the group on either side. In the other you can arrange people in rows, with the tallest standing at the back, others (the venerable and mature) sitting, and perhaps young children on the floor in front.

Arrange folks so that all their faces can be seen. Whether you choose a horizontal or vertical format for your picture depends on the shape of the group you choose—if it's wider than tall, go for horizontal; if taller than wide, go vertical. But rules are meant to be broken—if in doubt, shoot horizontal and crop later.

A natural prop, such as a staircase, lets you arrange people and is great for the informal shots, which, after all, are what most of us prefer. And be aware of the background—that can sometimes make or break a group photo.

Horizontal staircase grouping ▶
A wide staircase provided a convenient stage for this group, with the steps allowing the back row to be higher than the front. Stagger people so that no person's face is directly in front of another's.

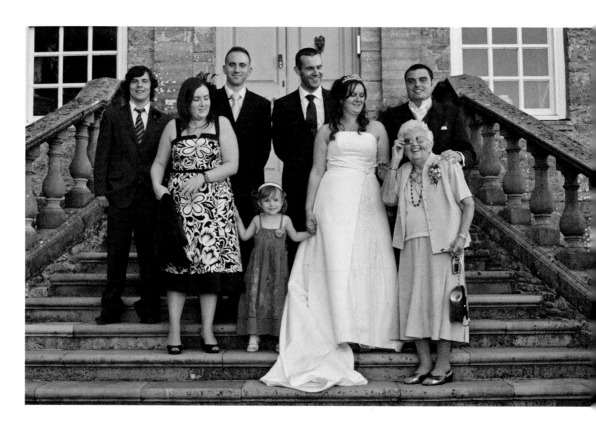

I want to take portraits of my children and their friends. What's the best way of posing them?

The simple answer is—don't! (pose them, that is). The worst thing to do with young children is to sit them down like the school photographer and wait for the cheesy grin, because that unnatural look is what you will get. Have the kids do something; children involved in an activity are fascinating subjects because they concentrate to the complete exclusion of everything else.

A zoom lens is a great help because you can focus on a group of children as they play and zoom in on one. Take plenty of shots (after all, you're not wasting film) and edit later; if you wait for the "the moment," as photographers say, then you're sure to miss some great shots.

Always try to fill the frame with the subjects— that is one technique that makes your pictures look more professional.

A word of warning: Stick to your own family, or the children of friends, and only take photos with the parents' knowledge and permission. That way it is safer for everyone concerned.

◄ **Lost in thought**
Whether camera-conscious or not, children are often easier to photograph when they are engaged in some kind of activity.

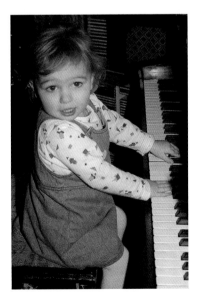

◄ **Budding pianist**
The grand piano was a magnet to this young visitor; the minute the camera appeared she posed naturally.

Which is the best way to take a portrait—face on, slightly to the side, or another way?

A Like so many things in photography, you never quite know until you take several versions and compare them. Many portraits are taken straight on, while sometimes a photo that shows a slight sideways tilt of the head, with the eyes looking directly at the camera, works well. A profile can also be effective as something a little different than the norm.

Most of us do not have perfectly symmetrical faces—noses bend a bit to one side, eyes and eyebrows are at slightly different heights, and so on. This is the reason that you hear people say they have "good side." Go with it and allow your subject to choose (even if you don't agree), because they will be much happier and more relaxed—and then you can work towards photographing the other side just to see.

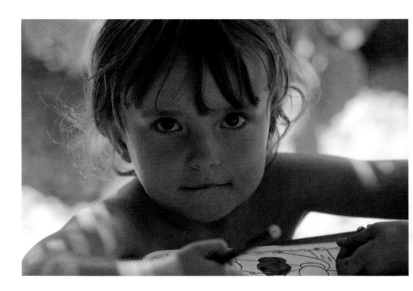

▲ Full face
A straight-on portrait immediately engages the viewer. Here my niece (and a favorite subject) shows no concern for the camera.

A direct frontal gaze can have a lot of impact. For this you need to get the lighting right—slightly more from one side than another (but not so much that you get shadows from the nose and in eye sockets). Setting someone beside an open window provides good portrait lighting. Many digital cameras allow you to use flash as well and, after a few tries, you will get a good balance of natural and artificial light. Remember to watch out for the distracting items in the background—plants or poles that seem to grow out of heads.

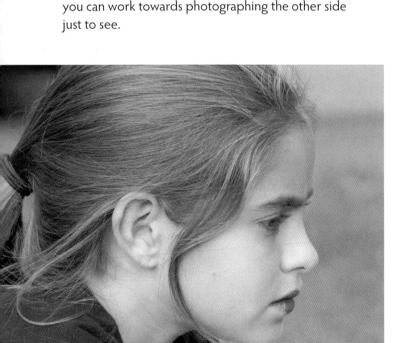

Photo © Kevin Kopp

◄ From the side
Moving to the side for a profile changes the perspective of a portrait. This girl was deep in thought—a direct gaze into the camera would have broken the spell.

How much of a figure should I include in a portrait—head and shoulders only, three-quarter length, or full-length?

If you had just one shot and could not decide, then you could take a full or three-quarter length shot and crop it on your home computer. But the result is never quite the same as taking a head-and-and shoulders shot in the first place. The reason comes down to perspective—with the head-and-shoulders photo you either stand closer or use a zoom to bring the subject closer. The farther away you stand, the flatter the result; the closer you are, the more you will accentuate the facial features.

Often the best way to show someone's face is the head-and-shoulders shot, so I usually take one of that type. But it is a good idea to try a whole range of photos: Move around to get slightly different angles, shoot from a bit below, or stand on something and shoot from above; then select the best photos later.

Keep in mind that there is much less chance of including distracting background objects as you move in close for a head-and-shoulders picture, while capturing a busy pattern or an unsightly telephone pole behind your subject is much more likely if you step back for the full-length shot.

▲ **Three-quarter lengths**
A high resolution, three-quarter length shot like this gives you the option of cropping later as a head-and-shoulders portrait—or even crop closer.

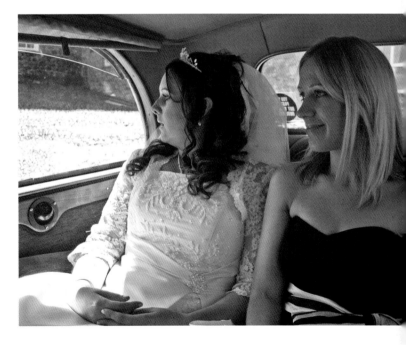

▲ **The big day**
I decided to get in fairly close with a horizontal composition to show this bride sharing a bit of natural apprehension with her good friend on the ride to her wedding ceremony.

I don't like posed pictures of people, so how can I get good, informal-looking shots?

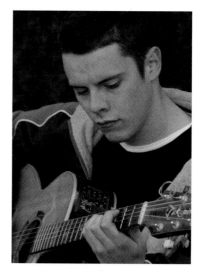

The secret to capturing informal people pictures is to make your subject(s) feel relaxed. This is easiest if you know the person in question. But a good portrait photographer can quickly put most people at ease. People relax more easily in familiar surroundings, and if you photograph them while they are occupied, you generally get a more interesting, natural shot.

Try to catch people unaware, before they become self-conscious. For a more candid look, avoid taking the picture if the subject is looking directly at the camera. If you are seating a subject to photograph them, try having them sit on a stool or the edge of a desk or table, and position yourself so that they have to turn slightly to look at you.

Teenagers who are overly conscious of the way they look are not easy to photograph. One option is to let them take their own shots, using the camera's self timer, and experiment until they're happy.

The older we get, the more most of us settle into our looks. Elderly folks often make wonderful subjects because they are more accepting of themselves, and the years have often added character to their presence.

◄ Preoccupied
To capture a natural, informal moment, look for somebody absorbed in a favored activity, almost unaware of their surroundings. As far as this young man is concerned, my camera and I do not exist.

▲ Harvest time
An old tractor proved a focal point for this informal group. I made no attempt to get them to look toward the camera; I simply recorded these folks as they were, engrossed in a discussion of the day's events.

top tips

- Talk to your subject to put them at ease

- Let them get on with what they're doing

- Place your subject in surroundings familiar to them

How does the red-eye flash adjustment work?

The red-eye effect is created by the reflection from the blood vessels at the back of the retina when the subject is looking directly at the flash. The procedure to reduce this is quite ingenious: The camera is set so the flash fires a quick burst just before the main flash goes off. The pre-flash makes the pupils of the eyes smaller, so there is less chance of reflection and the resulting red eyes.

If your camera doesn't have the red-eye reduction function, then make sure your subject is not looking straight at the camera. Alternatively, use a flash to the side of the camera if you are able to do so. Failing this, you can always try retouching the image on your computer, since many image-processing programs have a red-eye tool ready-made to eliminate this problem.

▲ Muffin the kitten
Like human eyes, a cat's reflect light (though green instead of red). When using flash, you need to make sure your picture does not look unnatural.

◄ Focus on the eyes
Eyes are the point of immediate contact. It is important that the eyes are sharp in your portraits, and essential that you avoid or eliminate red-eye.

Photo © Kevin Kopp

My camera has a Close-up mode, but my subjects often look blurred when I use it. Where am I going wrong?

Y ou are probably being too ambitious and trying to move closer than your camera can focus. Some cameras will not let get too close—the shutter locks when you are not in proper focus range. The solution is to simply move a little farther away and try again. Blurred images in Close-up mode can also occur when the lens aperture closes down to give a greater depth of field but the shutter speed becomes slower to make sure there is enough light to expose the picture.

The blur then results from camera shake. Ideally, the camera should select a shutter speed that is sufficiently fast enough to prevent this type of blur, but it is not always possible.

Remember, the slightest movement, either from your hands or from a breeze blowing on the subject, can create blur. So steady the camera by placing it on a tripod or by holding it against something. You can also set a higher ISO value; this will allow a faster shutter speed, but the trade-off is that you get could get a grainier image if the ISO goes too high (higher than approximately 400).

◄ Orange lily
Close-ups are possible with virtually all digital cameras. How close you can get depends on the model, but most can cope with shots that include a small cluster of flowers.

▲ Damselfly

The small damselfly was photographed in early morning light before the day warmed up. The light was not bright enough to use a small aperture and get a shutter speed quick enough to eliminate camera shake. Knowing the depth of field was limited I concentrated on the face: The wide aperture has created a soft background and pleasant effect.

◄ Passion flower

A few cameras offer a genuine close-up mode allowing you to take pictures within inches of the subject. You can do this with any digital SLR using a macro lens.

I want to take close-up shots, but only a small part of the image seems to be in sharp focus. How can I get everything sharp?

This is the challenge with all close-up work, but it is not impossible to achieve. Manual control can help: As you make the lens aperture smaller, you get greater depth of field (see page 59). This means more of the picture will be in focus. The closer you get with your lens, the smaller the depth-of-field becomes. Depending on how close your lens can focus, you may get within fractions of an inch. So, try the smallest aperture your camera will allow. Remember that there is always a compromise: You don't want such a slow shutter speed that the breeze creates blur in your picture. Many people who take close-up pictures work with flash because that freezes movement and allows you to use a small aperture.

For close-up enthusiasts with a D-SLR, one great tool is a macro lens, which is specially designed to function close to a subject. Most macro lenses meant for film photography produce life size (1: 1 ratio) reproduction, which means that the subject is the same size on film as it is in reality. Remember that a D-SLR has a magnification factor of approximately 1.5x (see page 35), so that a lens with a focal length of 100 mm on a D-SLR gives the same angle of view as one with a focal length of 150 mm on a 35mm film camera. Because of this crop factor, your close-up will appear 1.5x life size when comparing the same sized prints from the D-SLR and a 35mm film camera, a useful "accident" of digital photography.

Martagon lily ►
When you are very close to a subject, any tiny movement seems gigantic. Always use a steady support and wait for calm conditions whenever possible.

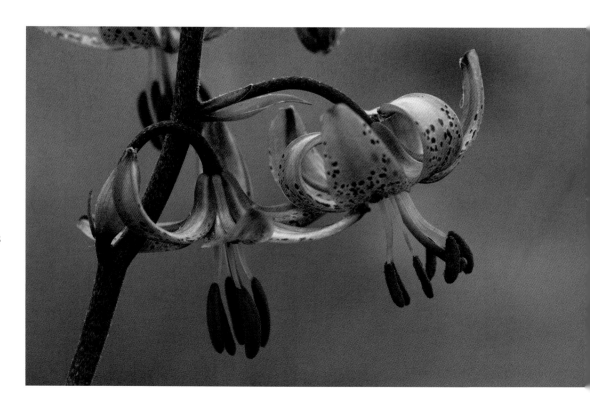

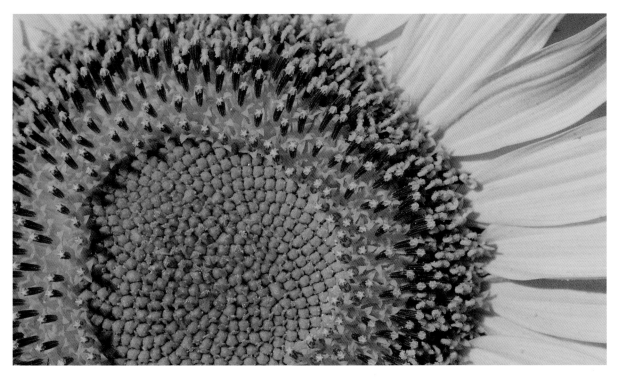

▲ Sunflower
Choosing the point of sharp focus is important. Set the aperture to achieve maximum depth of field.

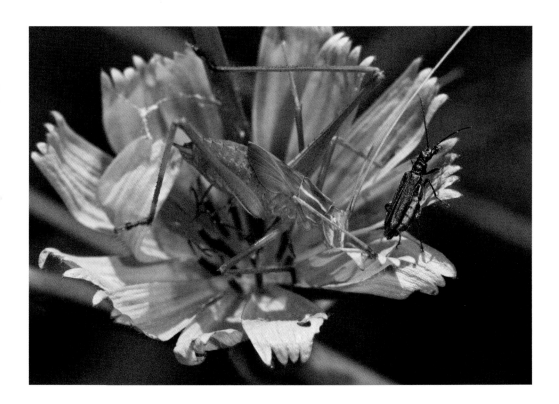

◄ Cricket and beetle on a Chicory flower
Flowers act as useful platforms for insects and provide a background for your pictures. Here flash was used to ensure enough light so that a small aperture could be used to give good depth of field—always a concern in close-ups. There was enough background light to give a natural result.

How do I set up several pictures to make a single, wide panorama?

You are going to shoot several pictures of successive portions of a scene, either horizontally or vertically, and then place them next to each, "stitching" them together on your computer. This way you create one big picture from several. To make this work, elements from each portion have to match so you can align the set of pictures. The question is how best to do it. A little bit of forethought will make producing panoramas much easier (see page 120). You want to keep several factors in mind:

Overlap—All the elements at one extremity, or side, of the picture must overlap to some extent with those in the next one of the progression, otherwise there will be spaces between the different sections of the panoramic image. It's not hard to judge this when looking in the viewfinder.

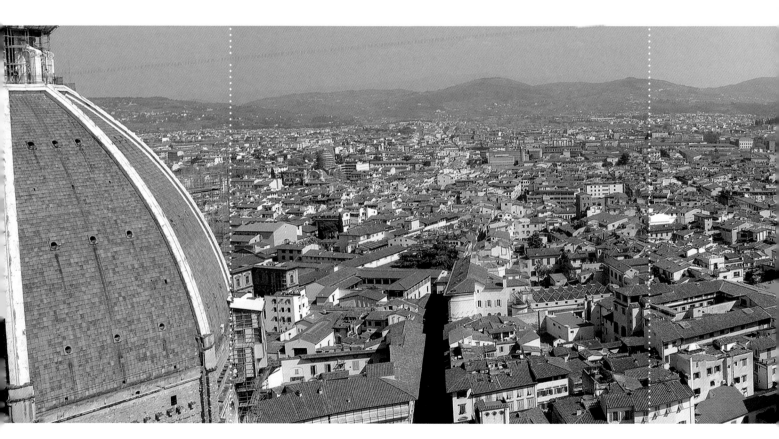

▲ **Taking photos for a panorama**
Make sure that you allow enough overlap between the constituent parts of the entire scene. That makes it easier, in this example, to match buildings as well the mountains' horizon from one photo to the next.

For example, if you see a tree (landscape) or a building (cityscape) in the right-hand part of the frame, make sure the same tree or building is clearly in the left-hand part of the next frame. You can stand on level ground and swivel, moving your feet slightly and not rotating your body so that the camera is always at a constant height (this way you won't to have to do much cropping or adjust horizon levels). But for best results, use a tripod with a head that you can set level and rotate as you take each picture.

Focusing—Set the focus when you begin to shoot the sequence and don't change it and don't zoom. Use a small enough aperture to keep both foreground detail and the distance in focus. If you try to correct focus or zoom, then you will have some pictures on a different scale from others.

Exposure—Try to keep the same exposure in each shot, so that areas of light and dark get recorded consistently from shot to shot. For this you have to lock the exposure or set it manually; if not, you will probably need to manipulate each of the photos in the panorama using image-processing software in your computer to match brightness, which is time consuming and is usually visible in the end result. Avoid getting the sun in the frame when it is high in the sky, as the camera cannot cope with the differences in brightness. Sunsets pose different exposure issues (see page 81).

The process may sound complicated, but the beauty of digital photography is that you can take as many trial shots as you need to set the camera controls. Then just stick to them and take the shots.

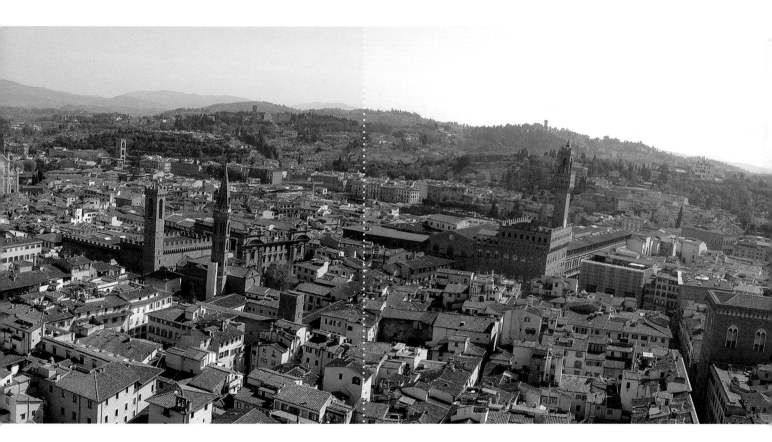

I want to take a black-and-white picture. Should I do this through the settings on the camera, or later through image processing on the computer?

Some cameras have settings for such effects as added saturation, making borders around the image, and recording a black and white, sepia, or tinted photo. These in-camera filters are certainly not essential since everything can be done later with proper software programs when you download to your computer.

Many people like the differences produced by these special effects. Try sepia to take yourself back in time, or shoot black and white of the bride and groom to produce a different look at a wedding.

However, when you set any of these options, the camera processes the results and data is lost. For example, a camera processed black-and-white picture loses all the color information—it can't be recovered. So in many ways it is sensible to make any color changes later, after you have seen the picture on screen. That way you have the color version on file and can then make any other shot you want from it.

There is no need to change resolution when you use these effects, but you can get away with lower resolution in a black-and-white or sepia-toned picture and create a "grainy" effect that works very well.

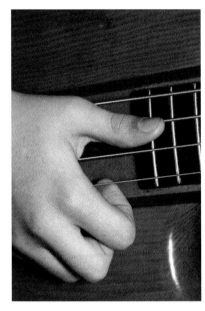

◄ Simplicity
Black-hand-white photographs have a simplicity that shows shapes and forms free of the distraction of color.

Revealing the texture ►
There is nothing like black and white for revealing textures. This shot was taken in color and then the color data was removed using one of several conversion techniques in an image-processing program.

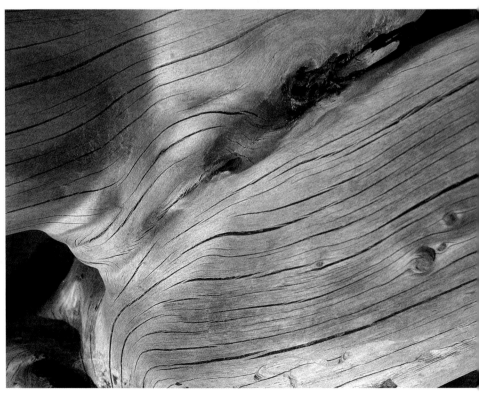

Sunsets look dramatic, but my digital camera does not always give me the colors I remember. Can I change this?

You are asking a lot of your digital camera while the sun is still in the sky at sunset: The camera has to capture a wide contrast range from very bright to dark. First, select the lowest ISO setting to help capture the subtlety of the tones. Then experiment. Take the first exposure at the setting the camera's exposure selects. Then compensate as needed—underexpose slightly and then overexpose by the same amount on another frame using the exposure compensation control.

If you have an exposure lock, take a reading from a part of the scene, lock it, and take the picture. Then repeat the process by locking exposure on different portions of the scene. You will see big differences in the separate exposures. Some of them won't be the colors that you saw, but they may be so rich and glorious that you will want to keep them. When you have a sunset you like, you can make subtle changes on your computer, such as adding a bit more yellow—the sorts of changes that happen as the sun gets lower.

A big difference in mere minutes ▶
The distinct color differences in these two photos show what happens in just minutes while the sun is setting. The atmosphere is colored by a yellow/orange warmth right before the sun disappears, and then turns predominately carmine, purple, and gray as the sun drops below the horizon.

When I take photographs of buildings, everything looks as if it's falling over. Can I change this?

Once upon a time, nearly every photographic magazine and book dealt with a problem called "converging verticals," which means that lines going upwards, such as the edges of towers and buildings, tilt toward the middle of the frame. These days people are not so hung up about it and many shots of buildings show a distinct convergence since it accentuates the impression of height. With the widest setting on your zoom lens, you can stand beneath buildings and get them to tower over you.

To minimize the converging effect, you have to be level with the middle of the building—for example by taking the shot from an opposite window or balcony. If you point the camera up or down, verticals either converge or diverge respectively. Some computer programs have controls that can help adjust these converging lines.

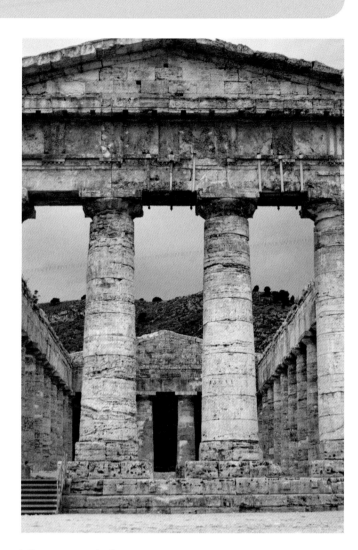

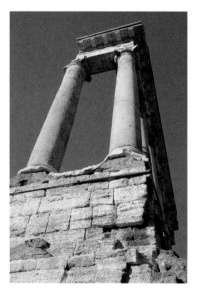

◄ **Converging verticals**
Once upon a time, converging verticals were frowned upon. Now they are an accepted part of the composition. In fact, stand in front of a tall building and convergence makes it seem to soar.

▲ **Correct verticals**
To correct verticals, first try standing somewhere slightly farther back and higher up so that you can see your subject without pointing the camera upward. Alternatively, you can correct perspective in the computer—but it takes a little practice to drag "frame handles" and get it right.

When I use my digital camera inside buildings, the pictures seem slightly red. Should I adjust this in the camera or later on my computer?

You often get an overall color cast when you have a scene where the light sources are mixed, such as daylight from windows and interior incandescent lamps. You can adjust this effect through your camera's white balance control, or later to an extent in the computer, especially if you have recorded using RAW format. But don't rely on fixing problems later, it is always best to start with an image as nearly perfect as possible.

If your camera has its white balance set for Daylight, then the photo will have a reddish or yellowish hue under incandescent lighting that, in moderation, looks warm. To reduce this you can set the white balance function to match the predominate source of light; in this case the setting for Incandescent (usually a light bulb icon). Or you can select Auto white balance and let the camera sense the proportion between the light sources. It is worth seeing if you can match color balance even more precisely by using the Custom or Manual white balance setting, which allows you to determine the actual light under which you are shooting. Use the camera's LCD screen to judge color cast.

At the theater — mixed light sources ▶
Faced with a mix of lighting, you can always set the white balance to Auto. If the result is unacceptable, change the white balance to a setting for the predominant light source, or set up Custom white balance if your camera allows. If shooting RAW, you can alter the white balance when processing on the computer.

Is it possible to take indoor pictures with candlelight or the glow from a fire?

The answer is a resounding yes. However, although your eyes can see perfectly well under these conditions, such low light levels are often outside the range of the camera's exposure meter, so you will need to experiment. The exposure could last several seconds—so set the camera on a tripod and trigger the shutter using a cable release (pressing the shutter button can shake the camera).

First, use the camera's meter and take a picture; then review the exposure on the camera's LCD. From the result, determine whether you must increase or decrease the exposure (lengthen or shorten the time the shutter is open).

Light from a candle is quite yellow, while that from a glowing fire is red. You might have to adjust the white balance for more realistic colors, although the effect is often pleasant without any adjustment.

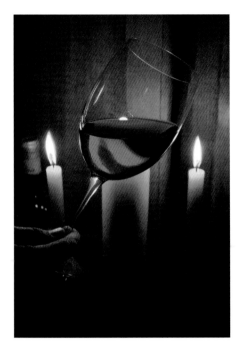

◄ Backlighting
Move the camera to capture the reflections in the wine glass. Slight changes in position affect the way the wine is lit.

▼ Adjust colors with the white balance
The camera's AUTO exposure mode combined with a white balance setting for Incandescent gave a good result in this photo.

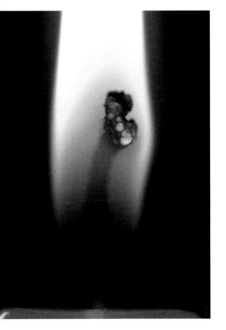

◄ Flickering light
Your eyes are much more sensitive than a camera and quickly adapt to low light levels. A camera, on the other hand, will require a long exposure to record the detail—so you are likely to get some flickering (movement) of a flame.

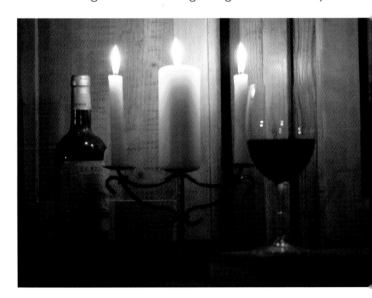

What setting should I use on the camera to photograph stained-glass windows?

Set up the camera as you would daylight photography, because that is what illuminates the window from behind. And set the white balance to Cloudy, because this warms colors (there are often reds and yellows in stained glass that benefit from this). Use the LCD as a "visual exposure meter" to review results:

If the shot is too light, underexpose it a little; if it is too dark, overexpose slightly. If it is difficult to see the result on the LCD screen, err on the side of underexposure. This way you will catch subtle details in the window that will become apparent when you view the image later on your computer screen without overexposing the light areas.

◄ **Check what's outside!**
This large window in a town house looked onto a wall outside that I did not notice until I checked the picture on the LCD. For this shot, I chose a portion of the window that was backlit by the sky.

Arched rose window ►
Even if a church is lit by artificial lights, the stained glass is backlit by daylight from outside. There may be a slight problem with bright areas being burned out, but this is easy to correct using exposure compensation and by looking at the LCD screen.

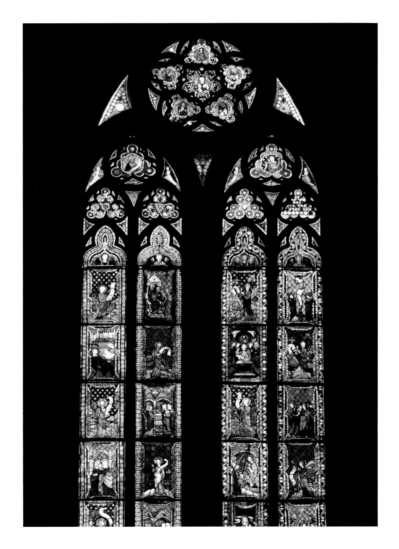

Is it worth taking pictures in the rain or should I wait for the sun to come out?

Obviously if you want to get pictures of puddles, raindrops, and people in stormy weather, you must take your camera out in the rain. But there are other very good reasons for going out with a camera when the weather is wet or dull. After storms, for instance, you get some of the most dramatic skies, and you may be lucky enough to capture a rainbow if the sun comes out behind you as you face the dark landscape.

Surprisingly, in rainy or dull weather you can get great pictures of gardens and flowers because in bright sunlight the contrast is often too high for your camera to handle, so bright areas get burned out. In addition, you will find that many colors such as red, orange, yellow, and blue have an extra zing in overcast conditions.

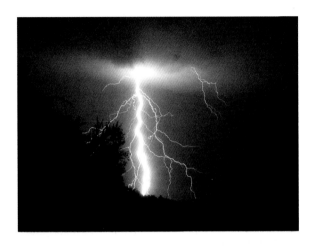

▲ Lightning strikes

The chances are fairly remote of pressing the shutter at exactly the right moment to capture a lightning strike, but it can be done. Especially at night, watch where a storm's general activity is occurring and use a wide-angle lens. Leave the shutter open for 20 – 30 seconds with the aperture set to f/8 or f/11. This way you may capture several strikes in succession, together with side discharges and the eerie purple glow in the sky that accompanies the ionization in a storm.

As artists (and florists) have long known, raindrops on plants make them look fresh. However, avoid getting raindrops on the front of the lens, as they act as small lenses and are visible when you look at the image later.

For a challenge, you could try photographing a lightning flash—or even several. It is easiest to do this with storms at night. Place the camera on a tripod and set a long exposure, perhaps for half a minute, as well as a fairly narrow aperture, approximately f/8. A wide-angle lens increases your chance of capturing the flashes, since you never know for sure where the flash will be. You may also get a purple glow from some of the background discharge of the lightning.

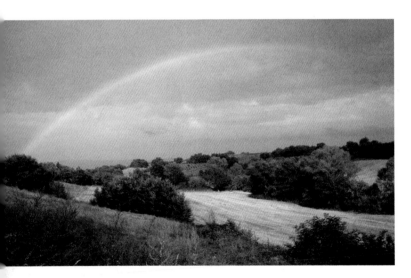

▲ Chasing a rainbow

Rainbows seem ethereal, so people are sometimes surprised when they show up well in a photograph. For dramatic effect, keep the sun behind you and a dark sky in front.

How can I avoid reflections when I try to photograph things behind glass?

Using a polarizing filter can diminish reflections from glass, but this is only reliable if you have a D-SLR that allows you to see the effect as you rotate the filter.

Try moving slightly to one side of your subject—although this is not effective when you want to photograph a painting because it will appear skewed in the picture. (This can be adjusted on the computer, but it is convincing only if the distortion is slight.) You may be able to stand in relative shadow in some galleries—that way you are not illuminated and don't create an obvious reflection on the glass.

It is possible to make an effective hood to place around your lens when photographing glass cases and aquariums (I have modified the water collector from a drainpipe and painted it black!). Black velvet or flock paper (sold in arts and crafts stores) with a hole for the camera lens works well. You can then press the front of your hooded lens against the glass, avoiding reflections. This works well provided the glass is clean; smudges or marks on the glass will cause softly focused images.

top tip

Always ask permission before taking photographs in galleries or public collections.

Red-eyed tree frog ▶
For this vivarium shot, I pressed the lens up against the glass and focused beyond; this way, spots on the glass do not show up on the image. I had an external flash that I held above the tank to avoid bright reflections from the flash.

How can I take good digital shots at night?

Although streetlights look bright, this is because your eyes adjust to the light levels. Even when lit, night scenes are usually much less bright than day time. To help get well-exposed photos, set the ISO to 400 or higher so you can use an adequate shutter speed. If you hear the shutter act slowly, you will know it is open for more than enough time to record camera shake. To get the required amount of light, the aperture will probably also have to be open wide—the Program exposure mode can do this for you.

It is always a good idea to have a support—a tripod or monopod. But even a bench or railing on which to brace the camera is better than nothing at all.

It is hard to freeze movement at night because the shutter is usually not open long enough to do so, even at a relatively high ISO setting. So you can often have good results if you work with the blur, letting it become part of your composition to suggest movement. Car lights, for example, leave trails that can look very cool.

A flash is great for lighting a subject—perhaps a face—in the foreground while the street lights provide the background. However, if the subject is too near, it may become burned out by the flash. Experiment to see what works—some cameras allow you to underexpose with the flash, so you can then fine-tune the exposure until the face is properly exposed.

▲ Full moon

A full moon is bright. At ISO 100 and an aperture of f/8 or f/11, an exposure of around 1/125 second will give a good result. However, the moon is moving, albeit slowly—and this movement is enough to create a picture that is slightly fuzzy. Using the same aperture, set the ISO to 400 and the exposure at 1/500 second to increase sharpness. Use a long telephoto lens if you want to capture the craters.

Trails from car lights ▶

Headlights and taillights of traffic make interesting patterns when you leave your shutter open for several seconds. You'll need sturdy support; a tripod is best.

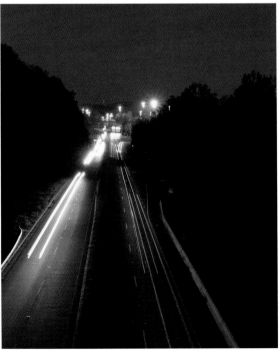

Photo © Kevin Kopp

When I use the built-in flash, the shots are sometimes too dark or too light. Why is that?

Small, built-in flash units can be effective, but they usually aren't very powerful and it is easy to roam out of their optimal range. Your subject may be too close for the aperture that has been set, so the shot comes out too light; or it may be too far away, so it comes out too dark. Use your built-in flash as long as you understand its limitations.

First try setting a wider aperture if your subject is underexposed because it is too far from the flash. If the photos are still dark, then set a higher ISO to make the camera more sensitive. If this also fails, then you are too far away—move closer to the subject.

At the other end of the scale, if you use a wide aperture close to your subject, you can flood it with light, creating overexposure. Taking a couple steps back or closing the aperture down to f/8 or smaller usually solves the problem. Changing the flash mode to Slow sync will also help brighten background areas of the shot. Alternatively, adjust the exposure compensation setting.

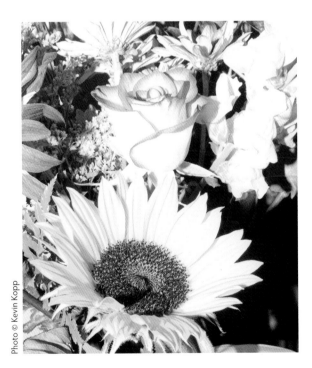

Photo © Kevin Kopp

▲ **Too close**
Here the camera with built-in flash was too close to the subject (about 1 foot, or 30 cm), over-exposing the flowers and completely burning out the highlights.

Photo © Kevin Kopp

▲ **Moving back a bit**
After examining the first shot (left) in the camera's LCD, the photographer took several steps back and zoomed to a longer focal length to retake the photo, this time capturing much more detail.

The best fireworks pictures are taken with a shutter open for a duration from several seconds to a minute or more. Exploding fireworks create very bright spots of light, so first you need to use small apertures, such as f/16 or f/11, if your camera lets you set them. A long exposure is necessary so that when the fireworks' trails spread, they "write" their picture on the sensor and you catch the whole cascade of light.

▲ Framing your shot
It's impossible to predict exactly where in the sky fireworks will explode, so take a wide-angle shot to be sure of capturing a large area. Crop later if necessary.

It may be worth purchasing a camera that has a Bulb setting (B) if you are interested in this type of night photography, whereby the shutter stays open for as long as the shutter release is held down. By letting the shutter stay open for a minute or more, you can often record several bursts of fireworks in the same shot.

For a challenge, try to include someone watching the display in the picture. Even if the shutter is open for a few seconds, that may not be enough time to expose the face—so help things along using the camera's flash. Set the camera to Manual exposure mode to capture the fireworks using a narrow aperture and relatively long shutter speed, and use a flash exposure to light up the face, making sure your subject does not move while the rest of the picture is being taken.

◀ Bulb setting
Use the Bulb setting, if your camera has one, to leave the shutter open for a minute or more and capture the trails of light.

How do I take underwater photographs?

Many people like to take pictures when they are diving. Digital cameras are ideal for underwater work since you can use a large-capacity memory card and not have to come up to change film after just 36 pictures.

Several companies specialize in producing secure housings made from acrylics or other plastics that provide a sealed environment for underwater photography. Camera controls are accessed from outside the housing via knobs. These protective housings depend on O-rings and other seals to make them watertight; the seals have to be perfectly fitted and checked regularly to make sure they do not deteriorate.

Photo © Dave Gaines

▲ Below the surface
Light falls off quickly when working below the surface, so special strobes are often used to record accurate images under water.

◄ Rock-pool photography
Rock pools are a treasure trove of small details. With your camera's close-up mode, it is easy to record bits of weed and colorful small sponges such as these. Make sure you don't disturb the water or it will cloud up and hide your pictures.

My digital camera operates on batteries. Can I use it in very cold weather?

Mechanical cameras that were used in very cold conditions used to suffer because the lubricants became more viscous and slowed shutter movement unless they had been replaced with special ones before a trip. Digital cameras are less mechanical (more electronically controlled) than older models, but they still have cold-weather difficulties because they depend so much on batteries—and all cells discharge far more rapidly as the temperature is lowered. There is nothing you can do about this, other than protect the camera from cold.

You can use a heavily insulated case, but it is easier and less expensive to remove the batteries or battery pack between picture-taking sessions and store them in your clothing as near to your body as possible. For cameras at the professional end of the market, you can get separate battery packs and run the cables down your sleeve from snug battery to camera.

◄ **Winter scene**
One drawback with a digital camera is that it relies solely on battery power—you have no mechanical back up. Use re-chargeable batteries and always have a spare set charged and available to avoid the problem of your batteries running out just when you need them.

If I pack my digital camera in my hand luggage, will it be affected by x-ray equipment at the airport?

Most of the fears about x-rays are a hangover from film cameras; there is no real evidence to suggest that airport x-ray machines affect digital cameras or damage memory cards. I've had photos recorded to CDs and other storage media that have passed repeatedly through airport scanning machines with no ill effects.

There is some concern about metal detectors, since they employ magnetic fields that can potentially affect digital devices—the handheld kind used by airport personnel is the main suspect. Some people suggest placing your camera as far away as possible from the beginning of the conveyor belts that carry items through x-ray machines to avoid powerful magnets in the drive motors. However, according to the U.S. Transport Security Administration: "None of the screening equipment—neither the machines used for checked baggage nor those used for carry-on baggage—will affect digital camera images or film that has already been processed, slides, videos, photo compact discs, or picture discs . . . The screening equipment will not affect digital cameras and electronic image storage cards."

◄ Playing safe
You can back up an image quite easily if you have a laptop or flash memory drive. It is a good idea to make copies when you are traveling so that you cut your risk of losing images if a memory card gets misplaced or if a file becomes corrupted.

How can I protect my digital camera from sand and salt spray at the beach?

It goes without saying that water and electronics don't mix—and salt water is especially corrosive. If you drop a digital camera in water, the repairs could cost more than the new camera. At the beach there is often a breeze and the air contains salt spray (which is harmful to the camera's electronic systems if the body is not completely sealed) and tiny particles of highly abrasive sand.

So, never wipe a lens after using the camera at the beach until you have given the front surface a few puffs with a blower brush or an air propellant to remove those tiny abrasive sand particles that will scratch your lens surface. Leaving a camera lying on the sand or a beach towel is asking for trouble. A protective case is essential and, for good measure, put it back in a bag. When you take the camera out of its protection, shoot as quickly as you can and then return the camera to its case until you are ready to take more pictures.

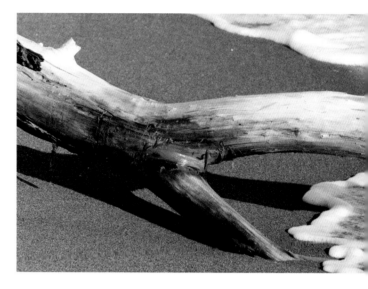

▲ Salt spray
If you take a lot of photos near the sea, then a soft plastic housing, available from camera stores and on-line, might avoid the need for expensive repairs later on. Saltwater and electronics do not mix.

◄ On the beach
To avoid tiny grains of sand working their way into your camera, keep it in a plastic bag or some other protection when it's not in use, and never leave it lying in the sun. Avoid taking it out when there is a breeze blowing since the air carries tiny abrasive sand particles.

If I want to take pictures in a hothouse or in a humid atmosphere, how can I stop the lens misting up? Will the moisture harm my camera?

The mist on the lens front is condensation—tiny water droplets caused by the camera lens being colder than its surroundings. If you let the camera warm up in the hothouse, the problem will go away. There are anti-misting sprays available of dubious efficacy, but when I was working on regular assignments in hothouses, I always traveled to the venue with my camera bag in the front of the car near the heater—pre-warmed.

Prolonged exposure to high levels of moisture is never a good thing for a digital camera, while more professional cameras have O-ring seals to keep moisture out. The most effective protection is to put the camera back in its case after every shot. After you leave the hothouse, take out the camera and wipe it down carefully. If you are staying for some time in a hot climate, then store the camera in a sealed case with some sachets of silica gel. This absorbs moisture, but to be effective the sachets need to be regularly taken out and heated above 212° F (100° C) to drive off the moisture.

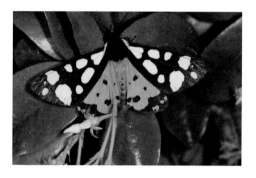

▲ Cream-spot tiger moth
Moths and butterflies often sit just out of reach, so a telephoto focal length is always useful when trying to capture them in photos. Identify locations where they feed (nectar plants) or bask in sunshine and wait for one to open its wings.

▼ Orchid Mantis on a Phalaenopsis orchid
Of all tropical flower subjects, I find that orchids are the most intriguing, especially when they play host to creatures such as this orchid mantis. Camera lenses will mist up when you go from a cold room into a hothouse, so allow time for the camera to warm up and check the lens to make sure condensation has gone before you take any pictures.

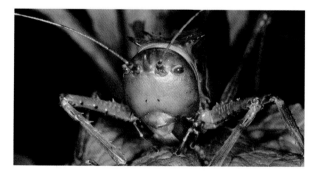

▲ Hidden and dangerous
This creature is completely harmless—although it does not look it! Far less innocuous are the molds that attack everything in tropical conditions. Keep cameras in cases when they're not in use and, on prolonged visits, pack things with silica gel to remove moisture.

Part Three

FROM CAMERA TO COMPUTER TO DISPLAY

Taking the photo is only the first part of the digital story: Add a computer, a photo printer, and some easy-to-use software, and you have complete control of the picture-making process from start to finish.

This section describes how to transfer your photos to the computer and explains how to carry out some simple adjustments to improve them. It looks at various ways in which you can use your photos, from emailing them to family and friends to making high-quality prints that you can hang on your wall or publish in magazines and brochures. Finally, it sets out ways of archiving your images so that you can retrieve them quickly and easily, and explains how to store them safely.

◄ Total control
Complete control of making images is in your hands from start to finish with digital photography.

How can I store digital images if I don't have a computer available?

The advantage of a computer is that you can edit and enhance your photos on a large clear screen and email them easily. If you don't have one, or do not want to take a laptop with you as you travel, there are excellent storage devices that allow you to download, store, and often view your images.

Portable hard drives—Rugged portable hard drives are extremely useful in the field where you can quickly download and back-up images from your camera to be viewed and edited later on a computer. Currently they range from 8GB to 250GB and beyond. Several manufacturers produce such devices that also have a viewing screen built in. The more expensive models give you limited editing facilities such as zooming and rotating pictures, and are great for trips where you need to travel light but want the ability to store and see your images.

USB portable flash—These are small devices, usually smaller than a pen, that fit the computer's USB slot with capacities to 16GB, enough for whole collections of images or slide shows.

Stand-alone printers—You can make prints without a computer by loading a memory card or CD with image files directly into a type of stand-alone printer made for this purpose. These printers often allow you to view the image on a small screen before printing, or they can also be connected to a computer if you wish.

Portable printers—Neat and easy to carry around, these small printers will display pictures from your memory card, flash drive, or camera on a viewing screen (that keeps getting bigger with developments in LCDs) and print directly. Often this type also allows basic image processing and lets you output directly to a television with a video input, as well as set up slideshows.

Home DVD players—Allow you to read and view the images that have been recorded and stored on a CD or DVD.

Retail photofinishing department—Of course there is always the option to take the card or CD to your local photo store. Many stores are equipped with machines that allow you to view, select, and print the photos yourself.

iPODs—These and similar devices allow you to download your photos and also to store and display them.

Fieldwork ▶
When spending time in the field without a laptop, you can find it useful to have a small, robust portable storage device with an integral screen to store and view images from your memory card. When you return home, you can download to a computer or play on a television screen.

How do I connect my digital camera to my computer or other devices?

Every digital camera comes with a port—a socket that allows you to plug in cables that transfer data—enabling you to connect it to a computer or other device. You need to know which kind of port is on your computer, and also which is on the camera before you buy cables. There are several types of connections that make downloading files quick and easy:

USB 2 (universal serial bus)—The beauty of USB is that it is "plug and play:" When you connect the camera, the computer recognizes it immediately without the need to reboot (start the machine again). You can connect a number of different devices (card reader, printer, flash drive, etc.) to your computer via separate USB sockets and, if you don't have enough ports, you can increase the number by using an external device called a hub. USB 2 transfers data very quickly.

FireWire (IEE 1394)—This is also a very fast type of connection, and, like USB 2, you can chain a series of devices together without the need for terminators. FireWire began on Macs, but now these ports are also built into a number of PCs. There are two versions: FireWire 400 and 800 (the faster of the two), and you can add expansion cards with FireWire ports to machines that do not have them. FireWire comes with different end connections, 4-pin and 6-pin being the most common.

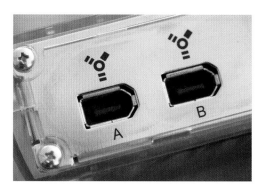

▲ **FireWire ports**
Mac computers and many others offer FireWire ports, which permit a very fast transfer of data from camera to computer, or between computers and portable hard drives.

Location work ▶
Some photographers find a laptop computer is invaluable, particularly for location work, since they can use it to download, store, and edit images on a screen that is much larger than their camera's LCD.

Is there any advantage to using card readers compared with just plugging in my camera to a computer

When you plug a card reader into your computer, it is recognized as another hard drive. Card readers are now so popular that they have become inexpensive, and because they can remain connected to your computer at all times, they are more convenient to use than connecting and un-connecting your camera via cable for every download (which can also drain the camera's battery). You simply take out the card from your camera, slot it into the reader, and download to a computer. If you connect the camera directly, then you cannot use it while the images are downloading—and that can take some time from a large-capacity card.

A number of readers can handle multiple card formats (CF, SD, SDHC, etc), and they are often faster than a cable connection from the camera, especially those meant for higher capacity cards.

The advantages of a card reader ▶
A card reader makes it more convenient to download regularly and free up space on the card in your camera—particularly when you are shooting high-resolution images with plenty of detail.

How do I decide which image-processing program to buy?

Many of the available image-processing programs do the same things: You can import an image, crop it, make different enlargements, make color changes, correct blemishes, sharpen the image, and much more. Rather than show a confusing array of examples of every available program, illustrations in this book show Photoshop Elements in use. Elements has many of the features of the full version of Photoshop, and many photographers (pros included) find its display area easier to use. The latest version is loaded with powerful processing tools, offering a number of advanced controls, along with a sophisticated image-filing and retrieval system that is a joy to use.

To help you choose a program, decide what features will be important to you and make sure that all the basic functions, such as downloading, cropping, resizing, and color correction, are easy to use. If possible, try using the program before buying—many are available as 30-day trial versions giving you time to assess its ease of use and facilities.

Photo © Kevin Kopp

▲ Which program?

There are many image-processing programs on the market, but Photoshop Elements has a work area that is particularly well thought out and intuitive to use. As you gain confidence in using it, you'll find you can do a great deal to enhance your images and produce eye-catching prints, slide shows, and web pages all from the same program.

Photo © Kevin Kopp

▲ Versatility

You can change many things with an image-processing program—size, color, and sharpness, to name but a few. You can even remove some elements of the picture and add others, while creative filter effects let you produce artistic (or plain weird) results.

How do I get an image into the program and up on screen?

Whether your images are loaded on a CD or downloaded directly from your camera into the computer's hard drive, getting a picture on screen is just like opening any other file.

Some computers have a default program that opens pictures when a camera or memory card is connected. Alternatively, you can view your pictures using the program that accompanies the camera in a software package.

One useful way is to use whatever image-processing program you have to open and transfer images for you. Through the preferences dialog box (usually found in one of the dropdown selections on the Menu bar), you can set the program to open when you click on an image or when you download. Or, open your image-processing program and go to File > Open and browse to find the image you want to work on.

▼ Opening the image

A simple connecting cable (USB or FireWire) carries image data from your camera to computer. Image-processing software can be set to open as soon as the camera is connected, so that your pictures are imported directly where you can work on them.

How do I crop and resize my images?

Using your image-processing program (illustrations here are from Photoshop Elements), select the Crop icon from the Tools Palette. This selection creates a small rectangle when you click anywhere on the image you want to crop. Click and drag the rectangle to enlarge it: Drag at the corner of the rectangle to increase the whole area; drag at the middle of a side and it lengthens in that direction.

Placing the cursor inside the rectangle lets you move the whole image. The area to keep in the picture is clear while the area to eliminate is masked (see the example to the left), enabling you to see what the result will be when you crop. Press Return to confirm and the crop is done. You can set the Crop tool to give fixed-size crops as well or use the rulers at the frame edge.

You can usually resize an image by going to a dropdown menu option, such as Image > Resize > Image Size as found in Photoshop Elements. Whatever your program, a dialog box will usually display that allows you to adjust pixel dimensions and document (print) dimensions in a choice of different measurements, including inches, centimeters, millimeters, and pixels. At the top of this dialog you will see the file size of the picture with its dimensions in pixels—useful if you're sizing for the web, for example. Below that in the dialog is the area for Document Size, including height and width measurements when making prints, along with the resolution box for pixels per inch (or per centimeter). Here you will want a size of 72 ppi for screen (web) pictures, approximately 240 ppi for making prints, and 300 ppi for photos that are going to be published in a book or magazine. As you change the values placed in the various dimension fields,

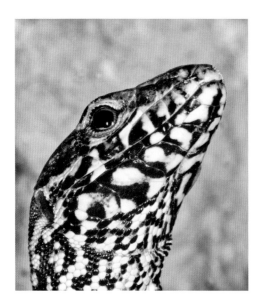

◀ **Cropping**
Cropping allows you to cut out part of the picture that you don't want. Click to select the Crop tool from the Tools Palette. A rectangle will appear on the picture and you can then change its size by clicking and dragging on the sides or the corners. Experiment to see what looks best.

keep an eye on the file size at the top of the dialog: If this gets bigger than its beginning value, you are adding pixels. (These are created by resampling, another name for interpolation—see page 15). You can sometimes increase the file size by 40 – 50% before details in the picture begin to look soft.

Check the Constrain Proportions box toward the bottom of the dialog: This maintains the ratio of length and width without cutting or squashing the picture.

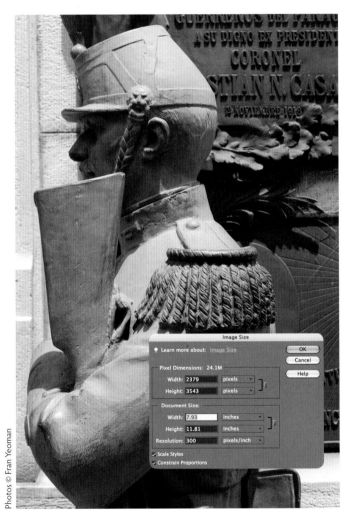
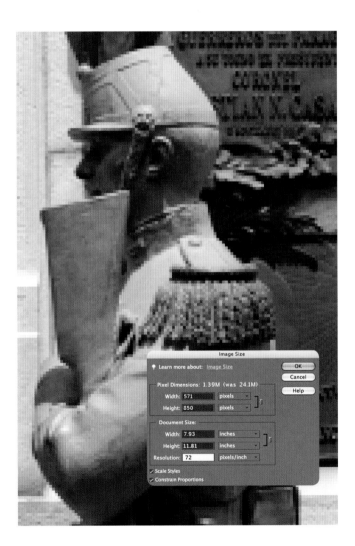

Photos © Fran Yeoman

▲ Changing file dimensions

When you want to change the size of your file, whether to make a high-quality print or to place your image on the Internet, adjust the resolution in the Image Size dialog while checking the box for Resample Image. Note that the image on the left, at 300 ppi, has a file size of 24.1 megabytes. Reducing the resolution to 72 ppi also makes the file much smaller—1.39 megabytes. While 72 ppi is perfect for emailing or web use, an image printed at that resolution will appear soft or pixelated, as you can see in the illustration on the right.

How do I change a picture that looks too dark or too light on my computer?

Image-processing programs usually offer a number of ways to alter brightness and other aspects of a picture. With Photoshop Elements, for example, you can let the program make adjustments under the Guided module, or you can select the Full module to take intentional and more precise control of additional processing options. After selecting the Full module, you will find a range of enhancement choices from the Enhance dropdown on the Menu Bar.

Among these choices, there are six Auto options—in each the program assesses your picture and makes adjustments to specific aspects of the file. These offer a useful starting point, but since the program controls the enhancements, sometimes the adjustments aren't really what you want.

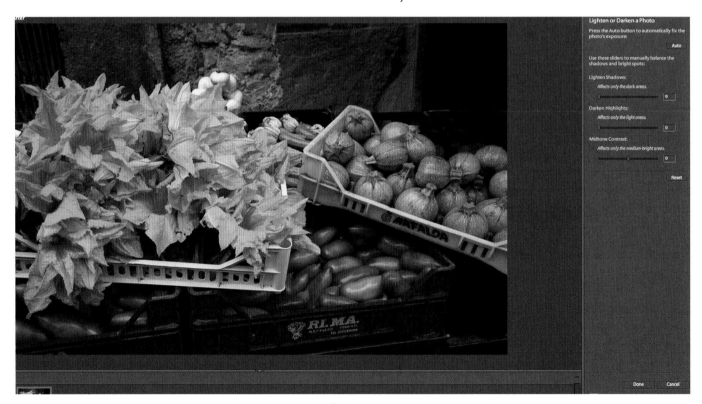

▲ Elementary editing in Elements
The Edit option in Elements' Guided module leads you step by step through several adjustment options, asking questions and giving you choices to perform desired enhancement tasks with easy-to-use sliders.

Adjusting brightness ▶

Using the Full module in Photoshop Elements, click on Enhance > Adjust Lighting for options that allow you to adjust the brightness of the photo. The Shadows/Highlights item allows for subtle control of the darkest and lightest areas of the image, while Brightness/Contrast (illustrated) can make dramatic changes in the picture.

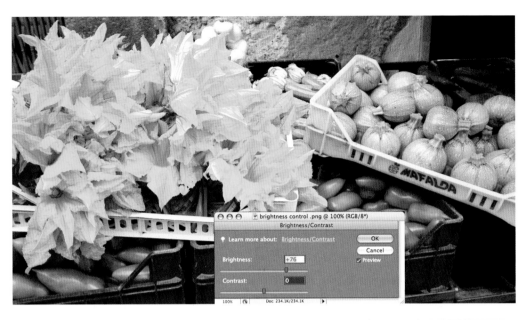

The Levels control ▶

Again in the Full module, select Levels for the most control over brightness. It is essential to experiment. Check the Preview box to see the results of moving the Levels sliders. You may find it useful to use the Auto Levels option found closer to the top of the list in the Adjust Lighting dropdown to see what can happen with a single mouse click.

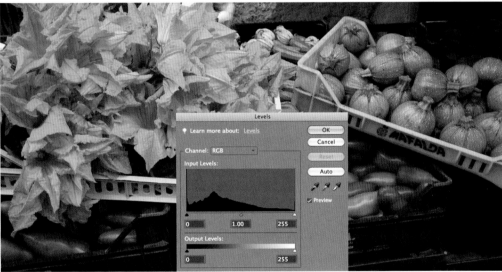

To place yourself in the driver's seat for more control over processing, go to Enhance > Adjust Lighting under the Full module and look for three additional options:

- Shadows/Highlights
- Brightness/Contrast
- Levels

These selections all produce changes in brightness, but to a different degree of refinement. Each displays a dialog box with sliders and a Preview box so that you can see the effect on screen as you adjust the sliders (uncheck the Preview box to compare your proposed enhancement to the original to make sure you have not gone too far). Shadows/Highlights is more subtle than Brightness/Contrast, and Levels is best for fine-tuning, allowing you to achieve a balance between brightness and contrast at the same time.

You can make adjustment for the whole picture or each of the color channels separately (red, green, or blue), which can create some weird and wonderful effects if you like to experiment.

My pictures lack contrast. How can I give them more punch?

Black and white images often suffer from lack of contrast and appear muddy, while colored images lacking contrast just look dull. You can enhance your pictures using image-processing software to increase contrast.

In most image-processing programs, find the Brightness/Contrast control. Using Photoshop Elements, this is found in the Full processing window from the Menu bar: Enhance > Adjust Lighting > Brightness/Contrast.

With a black and white, move the Contrast slider and note what happens. Moving to the left (decreasing contrast) produces an image with much less difference between light and dark tones, so the photo looks a bit muddy and gray. Moving the slider to the right (increasing contrast) makes the blacks look "pitch black" and the whites "pure white," emphasizing the extreme tones at the expense of midtones. Adjust the slider to achieve the desired effect.

With color photos, an image may transform into extremely vivid color blocks at the right hand (high

▲ Wood textures

These old wooden door panels in effect are monochrome subjects since there is not much color. They serve to show how important contrast is in revealing textural detail. The picture on the left is a photo straight from the camera before any contrast was applied from the Full module in Elements. Next the contrast was increased (right) to illustrate how that can result in a more vivid and attention-grabbing photo, though perhaps a bit too much in this case!

About right ▶

This well-exposed image with bright colors needs little change to its contrast.

contrast) end of the slider scale, creating an image that is less subtle where changes in tone occur. It is possible that some areas become blocks of solid color—an effect known as posterization. You will get the best results from subtle changes of brightness and contrast. For instance, making the image slightly darker (moving the Brightness slider to the left) and increasing contrast (Contrast slider to the right) gives a more "punchy" effect. Experienced Photoshop users go to Levels (and Curves—now omitted from Photoshop Elements) for more control, but most of the time the Brightness/Contrast control will do a good job.

▲ Dull and less attractive

Moving the Contrast slider to the left reduces contrast and produces a rather muddy picture.

▲ Delicious fruit

Many image-processing programs now offer a subtle control of midtone contrasts, useful in this photo to brighten up a fruit stall on a dull day.

▲ Punch it up

Raising contrast (moving the slider to the right) produces a more vivid effect with sharp changes between lights and darks in the picture.

Some of my images seem to have a color cast. Is it possible to remove or change it?

This is one area where digital photography really scores. Ideally, your computer monitor should be set up to give accurate colors that match what is recorded by your camera, and products are available just for this purpose: A device called a colorimeter, that comes with its own software, lets you calibrate your screen on a regular basis (since screens can change over time) and is available from several different manufacturers.

Sometimes on-screen colors in your photos don't look right and it has nothing to do with the monitor. The reason is due to the type of light in which the photo was taken—different sources of light have different colors! For example, light from a bright blue sky can make snow look bluish: Pictures taken indoors with a mix of incandescent and fluorescent lamps can have a greenish hue. Your camera's white balance control can adjust for the correct color at the time you take the photo (see page 38), but it is also possible if a mistake is made to adjust color casts on the computer, especially if the file has been recorded using RAW format.

Many image-processing programs have a control to change hue and saturation. It is possible to remove all color (desaturation) and create a black and white image, or go the other way to exaggerate all colors, oversaturating the photo.

Again, Photoshop Elements in the Full editing module has some very useful options for this purpose. The program can correct color casts automatically, or you can take control of managing the color. Using Enhance > Adjust Color, you will find options for Remove Color Cast and Adjust Color for Skin Tones that can effectively deal with many of the most common color cast problems. And the Color Variations option will display a selection of thumbnails that gives you an idea of what to expect from different color casts.

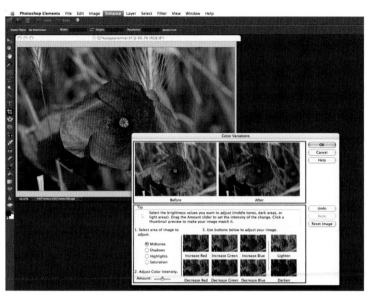

▲ Color Variations
This useful option allows you to see the results of different tints and then work to further refine them. Its application is most pronounced when the picture contains strong colors.

You can intervene directly to make color corrections using a Dropper tool that helps correct color casts. To explore this, select Remove Color Cast and click to activate: Your pointer becomes a Dropper that will neutralize overall color cast of the picture when you point and click it on areas that should be white, neutral gray, or black.

Select Adjust Color for Skin Tones and you can click on any skin area. Elements automatically adjusts the skin tones, but if you think you can do better manually, try the sliders for Tan and Blush.

Red poppy ▶
This photo of a poppy was well exposed and shows colors that are true to life. However, you can always experiment with digital to see different effects.

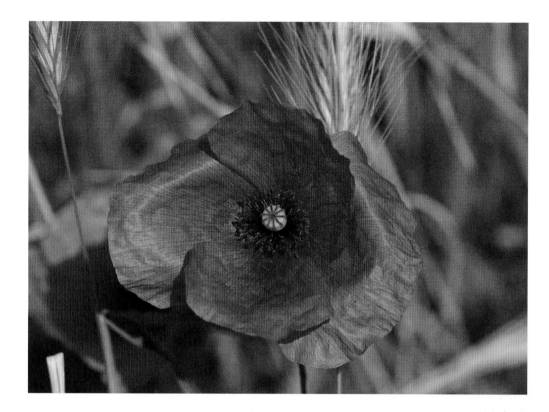

Getting blue ▶
Note the increased blue in the red portion of the flower and in the background, a result of applying the Color Variations option to this picture.

To what extent can I rescue an image that is out of focus?

You can't get away with poor photography and rescue every blurred image, but you can make an image appear sharper in print or crisper on the computer screen by finding the menu options for Unsharp Mask and Adjust Sharpness. In fact, any picture generated by a digital camera can use a degree of sharpening to offset one of the internal processes applied to eliminate a pattern that often develops (Moiré).

One of the most widely used controls to make images appear sharper is Unsharp Mask (USM). This sounds as if it will throw everything out of focus, but is very effective in making your pictures crisper.

The first thing to do in the USM dialog box is check Preview so that you can see changes on screen as they are made. Unsharp Mask assesses color and brightness variations and makes them more obvious by adding darker pixels, which is a little like putting tiny black lines around elements in a painting to accentuate them. In practice it is much more subtle than that, but the effect is, nevertheless, remarkable.

Making things sharper ▶
Many advanced compacts and most D-SLRs have a setting to adjust sharpening when recording images. However, it is usually better not to increase that setting too high in-camera, but rather apply sharpening in the computer, where you have more control using software tools.

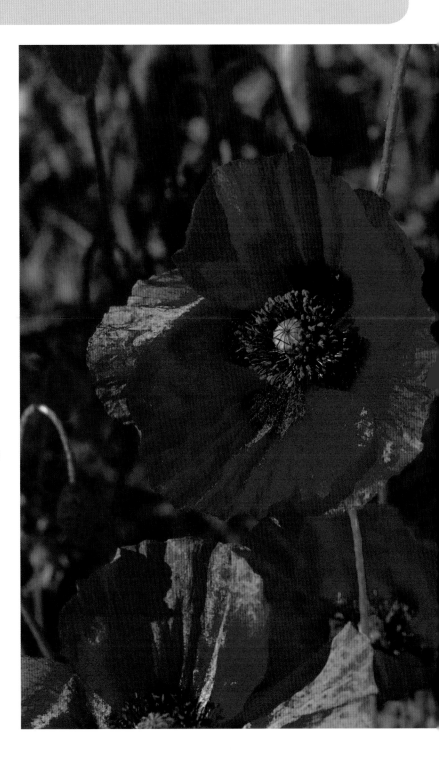

The values to place in the dialog box for Amount, Radius, and Threshold will depend on how big the file is. Using too much USM with a small file makes it look very grainy. Typical settings for different purposes might be:

Large files from an SLR (3600 x 2400 pixels at 300 ppi):
Amount = 120–200%
Radius = 1.5–1.8
Threshold = 1–3

Small files for web pictures (600 x 400 pixels at 72ppi):
Amount = 80%
Radius= 1–1.5
Threshold = 8

The option for Adjust Sharpness in Photoshop Elements provides compensation for different types of blur: Select Remove and you see three options: Gaussian blur, Lens blur, and Movement blur. Experiment with Amount and Radius and see what works.

▲ Using Unsharp Mask

You can rescue soft images to some extent by using the sharpening controls, but do not expect to perform miracles. Many sharpening filters, such as Unsharp Mask, pick tiny changes in contrast and accentuate them. Experiment within the parameters listed in the text to see what values work best in the Amount, Radius, and Threshold fields. Make a print to see what the changes look like, as it's not easy to tell from the screen. Above all, be subtle and avoid over sharpening.

◄ Using Adjust Sharpness

Adjust Sharpness is an "intelligent" approach to sharpening pictures based on the premise that there are different types of blur. Try the different effects and see what works. I find the Gaussian blur generally more useful than the others, though the USM method is more subtle.

The whole RAW business seems involved. What is the best way for me to deal with RAW files?

True, the process of using RAW files is a bit more complex than simple point-and-shoot photography, and when you download RAW files to your computer, you must use a RAW conversion program to open them. But despite the extra effort, this format offers advantages because you can alter and enhance the files to a greater degree without degrading them.

Using Elements, you will find an array of sliders when opening a RAW file with Adobe's RAW conversion program (Photoshop Camera RAW). Experiment with these various controls to see how you can make significant alterations to exposure, tint, hue, saturation, tonal values, and other image attributes of the RAW file. Don't worry, you cannot make any permanent changes to the RAW file unless you actually delete it (though you can save your changes to a different format, yet keeping the RAW file intact).

RAW processing in the computer allows considerable latitude for adjustment, but for the best result, exposure should be carefully controlled in the camera. Use the histogram LCD display found on nearly all D-SLRs and many advanced compact models to review your pictures. The histogram is a graph that indicates the quantity of pixels recorded at different tones, or brightness levels, and shows if the photo is over or under exposed.

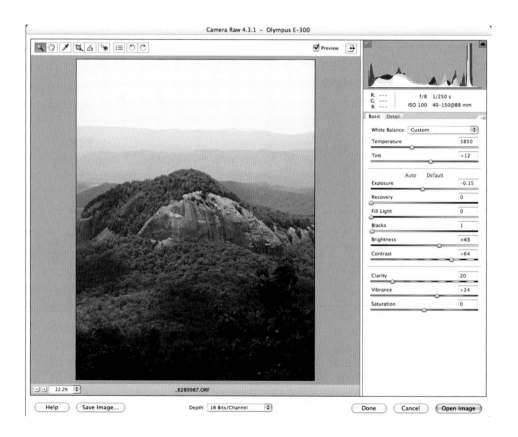

◄ **Elements interface for opening RAW files**
You will need a plug-in or stand-alone RAW conversion program in order to open and alter your RAW image files, and then save them as JPEGs or TIFFs to further enhance them in your image-processing program.

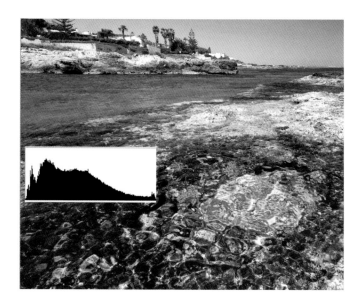

▲ Correct exposure

Creating the best images in the computer begins with recording the best possible files in the camera, even when shooting RAW. Proper exposure creates a balance in all areas of the picture so that there is as much detail as possible in both the light and dark portions. The graph of the histogram starts close to the left axis and extends very nearly to the right axis.

If your image appears too light, the histogram will be stacked toward the right side of the graph (above right). If the graph butts against the right axis, falling sharply, then highlights will be clipped, or lose all detail. Apply minus exposure compensation and re-take.

If the initial shot is too dark, the histogram will be heavily stacked toward the left side of the graph (immediate right). Shoot again and apply plus exposure compensation. To record maximum detail in both the highlight and shadow areas, the histogram should show a graph that starts near the left axis and ends near the right axis without clipping (above left).

You will also notice a histogram when you open a RAW file in Elements—or rather several histograms superimposed that show what's happening in the different color channels. With correct exposure as described above, these histograms should not show clipping. But just in case, you can always tweak the sliders to adjust the tone of the picture to your liking.

With practice, this process quickly becomes more intuitive and the quality of your photos will improve dramatically.

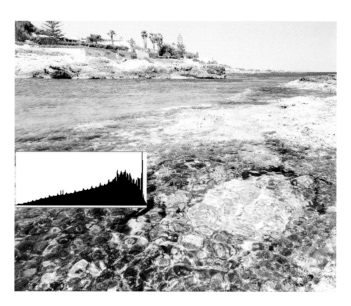

▲ Overexposure

You cannot retrieve detail when it is totally burned out due to overexposure. The graph of the histogram is skewed with most data in the right (bright) side and very little to the left.

▲ Underexposure

When an image is underexposed, the histogram's graph is skewed with most data in the left (dark) side and very little to the right. However, a good deal of digital data often remains in the recorded file even when a picture appears too dark. You can bring it out using a RAW converter.

How can I remove extraneous things from the picture—like people, telephone wires, or bushes; or even add things to one image from another?

Two of the most useful tools in Photoshop Elements and similar image-processing programs are the Healing Brush and the Clone Stamp found in the Tools Palette. The Healing Brush is great for "removing" small spots and blemishes. The program selects pixels from the area surrounding the unwanted blemish to blend them seamlessly and hide the flaw. The Clone Stamp lets you copy pixels from one part of your picture (or from a completely different picture) and stamp them on another portion, covering unwanted elements in the picture.

Always enlarge the portion of the image on which you want to work. To eliminate an unwanted object from a photo, place cloned pixels from the background over the offending area. Do you want to insert a person or element from another photo? Pickup pixels from that other picture with the Clone Stamp and place them carefully into the image, making sure both pictures are the same scale.

You can choose the size and type of stamp or brush from the menu bar at the top of the Elements window when you select the Clone Stamp or the Healing Brush. A slider alters the brush size, meaning the area of pixels that you copy. A stamp or brush that has soft edges will blend and often make the insertion less obvious.

Taking your time can make a big difference. Use a small brush and work on one small area at a time. Try not to move the tools using straight lines since it shows—especially if you sharpen the picture later. With just a little practice, you can become very proficient.

▲ **Removing blemishes**
This leopard had a bloody nose—from a scratch or perhaps from its last meal. To make this look like a normal nose, first zoom in. Photoshop Elements has a Clone Stamp that copies pixels from other parts of the image to place over the blemish. Dust spots and marks can be eliminated in the same way.

If I don't like the sky or the background in a shot, can I change it without it looking obvious?

You might want to change the color of a sky or remove it altogether and replace it with another one (maybe a few more clouds). This involves a process called selection. You can select a range of colors with a tool known as a Magic Wand, or select an area you want to change by drawing around it with tools called a Lasso or Magnetic Lasso. When the area has been selected, it will be surrounded by a flashing dotted line (the so-called marching ants). You can fill it with another color using the Paint Bucket or, through various menus, change the color balance, alter the brightness, or even sharpen (or blur) it.

However, no matter how careful you are with selections, you can often tell that something has been done around the edges when the shot is enlarged—it takes patience to get it right.

▲ Selected area desaturated
Most image-processing programs allow you to change anything within a selected area. Here the uniform color of the sky has been selected with a Magic Wand (notice the "marching ants") and the color desaturated to show a more gray effect. The color contrast has also been adjusted.

▲ A complete change of color
Experiment with tools such as the Paint Bucket after selecting an area in your photo for a color change. You may not want to print a salmon-colored sky, but this example shows how drastically you can change color if you prefer.

▲ Original shot
When you look at an image on screen, the sky or some other part might not be quite what you remember. Don't worry, you can change it.

How do I add text to the picture and make a card or poster?

In both Photoshop and Photoshop Elements is a feature called Layers that is a bit like placing a sheet of transparent acetate on top of the main picture and putting your captions, labels, or greetings onto the sheet. You can automatically create a text layer by selecting the Type Tool ("T") and clicking on the image to create an insertion point, which allows you to type a line of text on top of your image. If you want to create a paragraph, click and drag to create a text box.

Once you've created and filled a text box, you can move it, enlarge it, change the font, and create some impressive-looking effects through the Layer Styles. Once satisfied, you need to "commit" the layer, either by pressing the commit button in the options bar, pressing enter on the keypad, selecting a different tool, or by clicking outside the text box.

Photoshop Elements offers an extensive selection of theme designs for cards and photo layouts and, as with many other programs, there are ready-made templates for photo collages, greeting cards, and so on—you just supply the picture.

If you already have a drawing program on your computer, you can open a new page and copy a photo onto it by dragging. Now you can treat it like any other drawing. Create a text box that you can click on and drag to wherever you want. In the box, type your greeting and set the font style, size, and color.

Adding text ▶
One way of adding text to a picture is to use a separate layer. It's rather like drawing on a clear plastic sheet and laying it over a picture—allowing you to change the appearance of the typeface as you like.

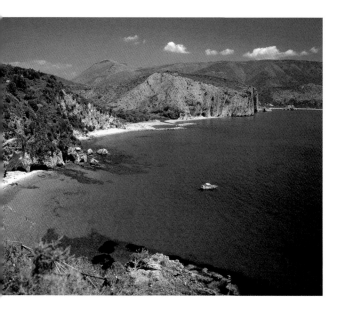

▲ Making sure that the text shows up clearly
Insure the words are easier to read by placing the text over an area of uniform color. You can shade the text, bevel its edges, or even position it on a curve to get a professional-looking effect.

Leave space for the text ▶
When thinking about a picture that you want to make into a card or brochure, leave enough open space for the text.

How do I stitch a series of landscape pictures together to make a panorama?

On page 78, we looked at how to use your camera to take a suitable set of pictures of a panorama. The technique on the computer is to use these overlapping images and fit them together so you cannot tell where each joins the other. This is why all the pictures should have the same exposure and be of the same scale. You can work with several images in your image-processing program, making sure you can see the overlapping alignment of the same object in the scene, such as a boulder, bush, horizon line, etc. To align them without showing a seam means working at or near individual-pixel level. This is not an easy task, which is why designers have now developed separate stitching or merging programs that do the aligning automatically and give a much better match in the blink of an eye.

In Photoshop Elements, follow this routine: File > New > Photomerge panorama. A browser window will appear that contains your images in folders, allowing you to navigate and select the ones you want to stitch together. Hold the shift key and click on each desired image file, and then click open. You can try to arrange things first and then let Elements take over to smooth out the areas where the images join.

Now check the box for Apply Perspective—start with 50% so that you get something that fits on the screen, and click OK. Elements opens, positions, and generally tweaks the series of pictures, ingeniously combining them to make a single image.

The finished composite is displayed on the Photomerge screen. The preview window shows what it looks like before cropping, and you can use the navigator with its red rectangle to travel over the whole image and enlarge sections to see how well it has worked.

▼ **The individual elements of the panorama**
I shot this series of four images to create a panoramic view.

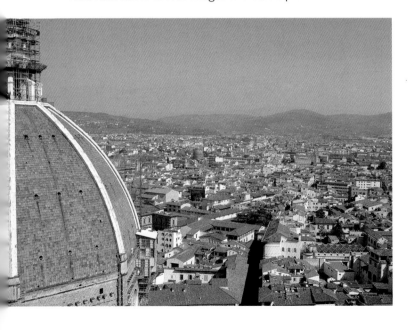

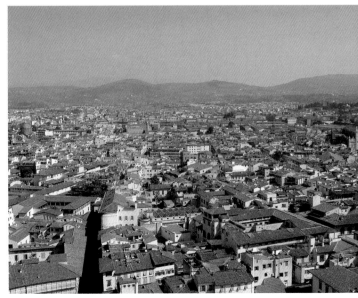

Creating a panorama in Photoshop Elements ▶
The Photomerge screen in Photoshop Elements displays the composite image, which you can then crop. By selecting Advanced Blending, you can also smooth out the "joints" between the different photos and ensure that the brightness is consistent across the whole panorama.

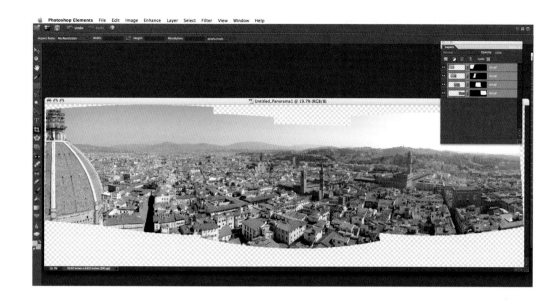

However, things are not yet finished. Go to Composition Settings, where you can flatten and blend parts of the image with Cylindrical Mapping and Advanced Blending; this cleverly helps eliminate differences where the photos join and matches brightness. The preview window lets you see the result. When you're happy click OK.

Your stitched panorama in the Elements editing window will almost certainly need cropping to remove overlaps from the top and bottom of the image. Click Fit in Window to see the final result displayed, then save it.

Now that I print my own pictures, what is the best type of printer for me?

The range of printers available can be confusing to beginners and experienced photographers alike. Before you buy, think about all-round use, the maximum size prints you might want to make, and of course your budget.

Inkjet printers—These are the most readily available and widely used, and the standard inkjet printer designed to print text can do a reasonable job printing photos if it has the right paper options that allow it to get the correct amount of ink on paper.

Photo printers—Also inkjet printers, but photo printers are designed more for printing photographs than for printing text. They are slower with text, but they give great results for printing photos and the best easily rival traditional prints when used with coated papers. But be aware that costs for printing inkjet photos can be high. Purchasing the manufacturer's brand of photo paper and inks can mean paying a premium, while use of cheaper inks can invalidate the printer's warranty and possibly lead to inferior printing. Many photo printers have individual ink cartridges. There are also continuous inking systems made by third-party companies that are more economical as you buy what you need and don't have to throw away a cartridge containing several colors just because one of the colors has run out.

If you want to print standard-sized prints and also have the option of printing text, then the good-quality inkjet photo printer will suit most needs and budgets.

Laser printers—More suited to printing text, which they do well at a high speed, color laser printers are expensive and are not best for printing photos because the picture quality does not match that of an inkjet.

Dye sublimation printers—This type creates great-looking prints—at a price. They do not print text and are currently only available with small print sizes, such as 4 x 6 inches (10.1 x 15.2 cm) up to 8 x 10 inches (20.3 x 25.4 cm).

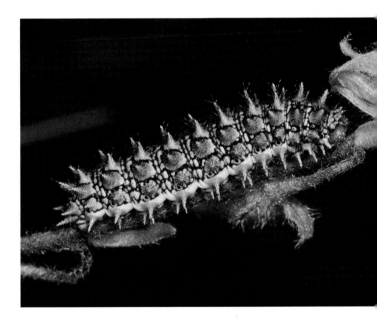

▲ Printer quality
Nature shots, particularly close-ups, need to be sharp and full of detail. With digital, excellent prints can now be made in your home. Although printers are relatively inexpensive, be aware of the costs associated with inks and paper. The best option is to buy a printer on which you can replace individual colors as they run out.

Features to look for:

The number of color cartridges: A separate black cartridge is preferable; four color cartridges is the minimum recommended for good quality results. Check that the color cartridges are separate so that you can replace them individually.

Print speed: Often given as pages per minute (ppm). A good average speed is 20 ppm (text), while newer photo inkjets can make a color 8 x 10 inch print (20.3 x 25.4 cm) in less than two minutes.

Resolution: Often noted as a figure, such as 5760 x 1440 dpi. This is the number given by the manufacturer to designate the quantity of ink dots per inch. This is not to be confused with the resolution of a camera's sensor or with the resolution of an image file, which are given in pixels per inch.

Print size: Standard printers will output prints at a maximum of 8 x 10 inches (20.3 x 25.4 cm). You will need a wide-format printer for prints up to 13 x 19 inches (33 x 48.2 cm).

Direct printing: The ability to connect your camera or the memory card directly to the printer.

Ink type: Check the type of ink used by your printer. Many are dye based, which gives good, bright colors that have fade resistance for approximately 10 years when used with care. Pigment inks last much longer, but are considerably more expensive.

◄ **Check your print colors**
Photos with strong colors and contrasts, such as the shot of these vegetables at an outdoor market, are a good way of checking how effective your printer is.

How do I print several pictures on one sheet of paper?

Using Photoshop Elements, you can print several images on the same sheet of paper by selecting an option for Picture Package (File > Picture Package). A window opens with options to select a number of preset layouts that determine quantity and size of pictures. You can make all the pictures the same size on the sheet, or have some large and some small.

Once you have a picture on screen in Elements, then all the picture boxes in the package will have this image. If you want different images on the same package, click on one of the picture boxes to replace; this brings up a new window: Select Image File. Browse your image folders to find the image you want, then click to make it appear in the window.

As a variation, it is sometimes useful to print thumbnail images, called a contact print (File > Contact Sheet II), of all the pictures within a folder or on a CD.

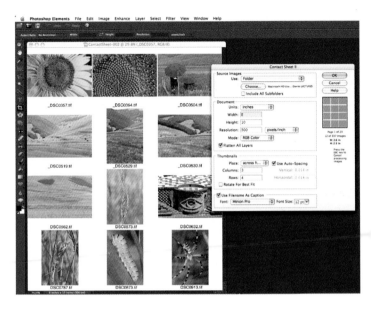

▲ Contact print
For easy reference, it is useful to print a contact sheet that shows the different images stored on a disc. You can generate one automatically in Photoshop Elements (File > Contact Sheet II).

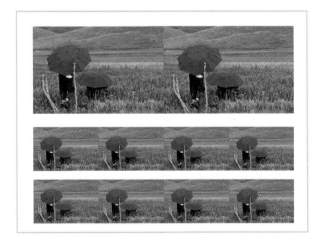

▲ Different sizes of photo on the same sheet
A particularly useful feature of Picture Package is the fact that you can arrange different sizes of prints on a single sheet.

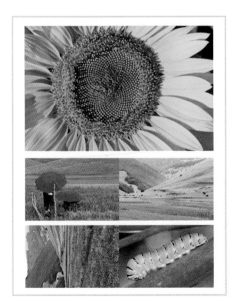

◄ Several photos on one sheet
To produce a print contain-ing different pictures, select the Picture Package feature in Elements (File > Picture Package) and set up the format you want from a single photo, then click on any of the picture boxes to select a custom file to appear in that position.

I can't get the printed colors to appear as they are on my computer screen—can I change this?

It is possible to adjust the way images look on your monitor and as prints by making use of files called profiles that help make sure your display and prints are accurately color-matched. You will need to consider the calibration of your monitor, the color profiles of your printer, and also the type of paper that you're printing on. Many people use standard ICC color profiles (supplied with a printer)—a set of computer instructions that match colors between camera, screen, and printer.

The way you view the image on your computer screen and as a print on paper will differ—check that your screen is not set too brightly and don't work with direct light on the monitor. Are you going to view your prints in daylight or artificial light? The dyes will give slightly different results, so set things up in the conditions you will most often use.

If your printer has a persistent color cast, you can try to correct this on-screen (see page 110). To make a difference at the printer end, you may have to make changes on the color sliders in the print menu, or try to adjust the printer through its control panels.

Sometimes problems arise when you use different papers, even those from the same manufacturer, because they absorb inks differently, creating color casts (often magenta). Test with some samples, decide what your stock paper will be, and then set that up as a default.

Balance screen and printer ►

If your first prints are disappointing, you may need to balance the computer screen and printer with a color management system that includes profiling software and a colorimeter. This is somewhat expensive, but is the surest way to assure accurately colored prints. Choose a photo that contains a range of different colors to use as a test.

I want to get some large prints made. What size files do I need to start with and how big can I go?

At home, the final size of your print will ultimately be determined by the maximum size of paper your printer is able to handle. But the resolution of the printer (dots of ink per inch) and of the image file (pixels per inch) will determine the sharpness of the final print.

To determine how big your file needs to be, look at it with the Image Size dialog box (see page 105) open.

The resolution will determine the height and width dimensions, as long as you are not resampling. Accepted wisdom states that a resolution of 300 ppi is required to get a sharp print, because the printing industry uses 300 dpi with its dot screens. But in reality, it is difficult to tell the difference between 180 ppi, 240 ppi, or 300 ppi when a file is printed on a good printer. What's more, smaller file sizes use less ink, print more quickly, and will result in a larger-sized print.

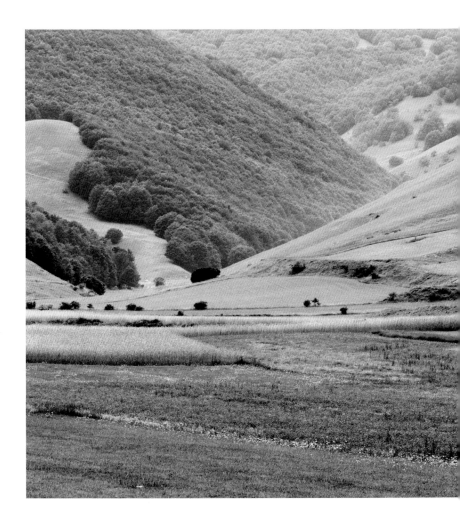

Shoot at maximum resolution ▶
To make large detailed prints you need big files—so if you think you will want to make large prints, shoot at the maximum resolution your camera is able to provide. You can easily reduce file sizes if necessary, but you cannot create detail that is not there in the first place.

Specific program for large prints ▶

Some photographers use Genuine Fractals and similar programs when making huge prints. The image data is coded in such a way that patterns in the image are identified and preserved (pixels are not just added at random) and you can make giant enlargements while still retaining tremendous detail.

There are lots of different inkjet papers on the market, as well as cards. The names are confusing, so what should I choose?

The best papers for printing your photos are coated with a layer that includes a type of clay or other substance so the inks do not blot and smudge. The sharpest and often most pleasing photos generally print on glossy photo papers, with premium papers usually having a better resistance to fading. The list below details the different types of papers.

Look at the weight of the paper, which is often given as gsm (grams per square meter). The higher this number, the heavier and thicker (and more expensive) the paper will be. Some printers will have difficulty feeding the heavier papers through. A good, standard paperweight is 255 gsm.

Plain paper—Good for test prints and for printing text.

Inkjet paper—Coated paper, good for draft-quality prints.

Photo paper—Designed specifically for printing photos, has a bright white coating and is the best choice for most prints.

Glossy photo paper—An expensive option, but with excellent results that give the brightest color and finest sharpness. Glossy is closest to that of a traditional film print.

Greeting-card paper—Available in many different colors, finishes, and weights to suit your project. Make sure that it is suitable to your printer.

Check how a paper handles colors ▶
A photo with a wide range of colors will let you see what the paper can do. Does it handle reds, greens, and blues well? Is the result sharp and bright?

top tip

Always print on the correct side of the paper; this is usually the glossy or shiny side. Printing on the wrong (more dull) side is a simple mistake—it sounds stupid but it's a mistake we all make once . . . at least.

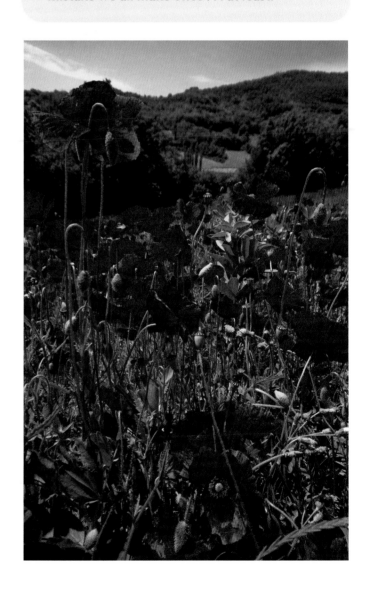

Know your paper ▶
I first printed this image on a photo paper that was new to me and noticed a slight magenta cast. Since I wanted to match the print exactly to my image on screen, I decided to revert to a paper I knew would work rather than waste paper and ink trying different computer/printer setups.

▼ Gloss finish
A good paper will print colors that are crisp and not muddy. Gloss usually scores over matte finishes if you want the most "photorealistic" results.

I have heard that inkjet prints fade with time. How do I prevent this from happening?

Early prints made with inkjet printers faded horribly when exposed to sunlight, even at low light levels. Ultraviolet (UV) light was the main culprit, but many prints faded even though they were in a closed drawer, simply because the dyes were not light stable. Things have improved dramatically with better papers and inks—but if you want your prints to last, then there are some steps to follow:

Inks—Archival inks are more light-fast. Generally, pigment inks (with tiny particles of pigment) last longer than those based on dyes.

Papers—Coated papers are produced that claim a longer print life. They are more expensive than basic photo papers, but if you're going to take the trouble to get something framed and hang it on the wall, then it is worth making sure it will last.

Varnishes—A varnish is a lacquer spray-coating that adds a protective surface to the print and resists the UV light that causes fading. Following manufacturers' instructions, spray in several passes vertically and then, after a few minutes drying time, spray horizontally.

Storage—Prints will resist fading if you keep them out of sunlight. If they are to be displayed, then use pigment inks together with a UV protective spray and put them in a frame with a glass cover.

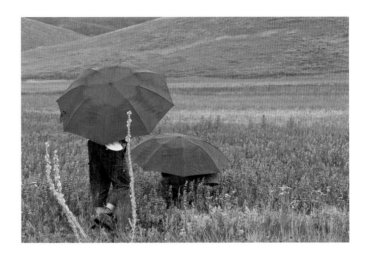

▲ Ensuring longevity

With time, exposure to ultraviolet rays affects dyes—even if the colors are strong to begin with. If you display your photos, use a UV-resistant spray and then mount the print behind glass.

▼ Inks versus dyes

Pigment inks keep their colors longer than dyes but are not as subtle—not a problem if you want a really vibrant print.

How do I store images on my hard drive and how many can I fit?

When you connect a camera or card reader to your computer, the images can be copied into a folder on your hard drive. Label the folder and store it there on your computer. You can improve organization of your filing system—and find images more easily—by setting your camera to give sequential numbering (through on-screen menus), so that one set of images begins its numbering from where the previous set ended. It does not matter what the numbers are, as long as they are different. If you use more than one camera, you can code each set of numbers so that you know which camera they came from. For tips on organizing your folders, see page 135.

If you like to record high-resolution images, even a huge hard drive begins to fill with these large files at what seems a frightening rate. You can add to your hard drive, but it is sometimes simpler, and safer, to download to CDs or DVDs as a storage option.

The number of images that you can store depends on the file format and size. TIFFs are lossless files that do not lose data when saved. JPEG files can be compressed to different quality levels with some loss of data to make better use of available storage.

top tip

Keep back-up files—A separate hard drive to archive your images is a good insurance policy. Never keep just one copy of your files: Store in two or more different places to reduce chances of loss due to file corruption or computer crash.

The table shows the approximate number of digital files you could maximally store without extra compression. The numbers are a guide to the size of hard drive or the number of DVDs or CDs that might be required to store a collection. In reality, most people store files that are an assortment of different sizes and image qualities.

QUANTITY OF IMAGE FILES SAVED TO DIFFERENT STORAGE MEDIA

File type	1GB Memory card	700MB CD	4.7GB DVD	200GB hard drive
JPEG basic	1,100+	775+	5,300+	220,000+
JPEG normal	550+	390+	2,500+	110,000+
JPEG fine	275+	200	1,250+	55,000+
TIFF	55+	40+	265+	11,000+
RAW	90+	65+	450+	18,350+

Will I need much more computer memory when I start processing images on my computer?

The truth is that you can never have too much computer memory. There is, however, a distinction between a couple types of memory that are used: RAM (Random Access Memory—what the computer uses to perform program functions and calculations) and ROM (Read Only Memory—the hard drive, CF cards, and any ancillary hard drives, as well as CDs or DVDs used as storage).

Get as much a RAM as you can with your computer and find out if you can add more in the future as your needs increase. As new versions of image-processing programs appear, they require more RAM and your work can slow down dramatically.

If you handle relatively small images (for example, up to 10MB), then you probably will not encounter problems while using approximately 1GB of RAM. But files can grow quickly, especially when you have made changes in Photoshop and have layers that you want to preserve.

You can always add hard drives to increase storage as needed—either as external devices or as second and third internal drives (if the computer has space). USB 2 and Firewire connections let you connect external storage and back-up drives. DVDs can also be used to archive photos since they hold about 4.7GB (with more on double-layer, and with greater capacities promised): 4.7GB represents nearly 200 files of 24MB each, or a much larger quantity of smaller files.

If you live in an area that has frequent storms, it makes sense to invest in an anti-surge device for the computer to protect precious memory chips and file storage.

File sizes ▶
Hard drives fill up quickly because image files are getting bigger all the time as cameras are produced with higher and higher sensor resolutions. You will need big files, however, when you want to retain detail in your pictures or want to make large prints.

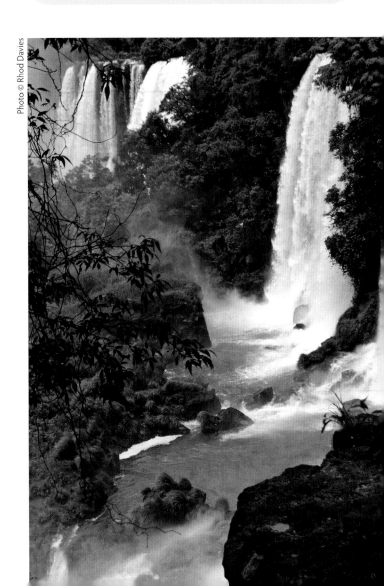

Photo © Rhod Davies

I want to make my own Photo CDs and DVDs. Is this easy? Can I get commercial prints made directly from them?

Computers these days are equipped with drives that copy files and burn them to CDs and DVDs, providing a simple and cost-effective way of storing files. CDs bought in bulk are relatively inexpensive and are a great way of sending image files to friends and clients.

When you have written your photos onto a CD or DVD, you can take them to a photofinisher where they can be output onto paper, sometimes using not just inkjet printing, but perhaps using such a technique as dye sublimation that looks even closer to a traditional print. Before you write the CD, find out what format the print shop requires; as a rule everybody can use JPEGs or TIFFs, and these are tried-and-tested formats for writing files.

▲ The benefits of a large screen
This church interior at Noto, Sicily, taken with an ultra wide-angle lens, contains many details that really pop when displayed on a large screen. You can use a DVD player and television to view individual images or slide shows (in a format such as Adobe PDF) when you burn you images to a DVD.

▲ Archiving pictures
It is amazingly easy to amass hundreds, even thousands of picture files. High resolution, fine compression (high quality) files can be from 25 to 50MB each, filling CDs rather quickly. The higher storage capacity of DVDs can help with the archiving dilemma.

Can I change a file into a different format, such as JPEG or TIFF?

A Image-processing programs allow you to change file formats easily. And though you can certainly convert JPEGs to TIFFs, even Large resolution/Fine compression JPEGs are much smaller than TIFF files, and you would be hard pressed to see qualitative differences between them. So be sure the trade-off in storage space is worth the quality difference.

To change format, select Save As from the File menu and then pick the option you want. The dialogue box then asks you to specify the file type, to give the file a name, and to choose where you want to store it.

◄ Fine JPEG
This picture was taken with a D-SLR as a high resolution/fine quality JPEG. It was enhanced and saved as a TIFF using image-processing software. Compared with a picture shot directly as a TIFF, there is no discernible difference.

▲ RAW format file
More experienced and serious photographers often record using RAW format to keep all of the original picture data. RAW conversion programs offer increasing capabilities to enhance and catalog RAW files, but many photographers still convert copies of the image to JPEG or TIFF for additional image-processing (cloning, layers, etc.) and to print.

I used to get in a mess with slides and photographs—how do I organize my digital files?

It is best to file your pictures into an organized system as soon as you download them to your computer—otherwise it is too easy to create an overwhelming backlog and you will not be able to find a photo that you want later. Find a system that works and stick to it. It pays to spend a little time creating captions and/keywords to make it easier to retrieve photos in your filing system or to make special collections of shots that you can upload to your website.

If you enjoy taking snapshots of friends, family, or vacations, then you might organize by date so you create a discrete folder each time you download from your camera or card reader; or alternatively, you could set up a series of folders with labels for friends, places, or vacations—anything you like, really.

Many people with growing collections utilize image-processing programs that have a strong cataloging component, such as Lightroom from Adobe, which works seamlessly with recent versions of Photoshop. It is principally geared to those who work with RAW,

but it can track other files you may have. Aperture from Apple for Macintosh users is also a very good program for this use.

Lightroom is a superb investment for those who take photography seriously. It allows you to import files and/or move them to another location, such as an external hard disk. You can name the files and even assign keywords as you import. And you can display all the files from that shoot, as well as sort, label, and preserve shooting data (f/stop; shutter speed, focal length, ISO, etc.). As you process files in Lightroom (particularly RAW files), the beauty is that you have not touched the original—that is part of your archive, but all the corrections and changes you make are tagged to the file that is automatically cataloged by the program.

Label your pictures in the database by filling in existing boxes with details. Then, at a later date you can search for keywords, such as flower, bee, or insect, for examples. The program then connects all the pictures together that satisfy these criteria and makes a display of those images on screen. You can even add more keywords as your collection grows and you think of more things.

Devising categories ▶
Accurate labeling is essential to find your pictures at a later date. Travel subjects, such as this fountain in Syracuse, Sicily, could be categorized not just with a label for geographic location, but by date of the trip or with the keywords of statue, fountain, or even horses—anything that makes sense to you.

How long will my digital images last?

Uv light causes dyes to deteriorate, so color prints fade over the years, as do color slides. Black-and-white prints last longer, but whenever they are exposed to light, fading is inevitable. Museums and galleries use various methods, such as using acid-free papers, to prolong the life of prints. Naturally, we want digital pictures to have the same longevity, if not better. One approach is to use papers and inks that will give a long life (see page 130).

But what about the digital files themselves? We all know how quickly computers advance and storage media change, with the result that we may well accumulate piles of older files with no means of reading them.

▲ **Keeping your memories**
Precious times in young lives are things you will want to keep forever. Make your prints on high-quality paper and store them away from light in files or albums. And be sure to transfer files to new storage media as the technology advances over time.

To allow for changes, think about copying old files onto new media every few years. Also remember that files can and do become corrupted—magnetic fields affect storage media. And though CDs and DVDs do not have the life and indestructibility that was part of the hype surrounding their launch, they are currently a cost-effective way of storing the image files you amass over time until something better comes along. But it is a good idea to pay more for the best quality you can afford—cheap CDs/DVDs pose a risk to your precious images.

Always store CDs and DVDs in jeweled cases and keep them away from bright lights, dampness, and extremes of heat and cold. Manufacturers often estimate potential lifespan of a few decades, but the reality is that we simply do not know how long CDs and DVDs will last. The best we can do is to maximize their life by taking good care of them.

▲ **Preserving images**
If you record things that are becoming scarce or disappearing altogether, such as rare flowers or ancient buildings, then your images need special care. Archive only on the best quality CDs and DVDs to provide as long a lasting archive as possible.

What do I need in order to view my pictures on a television set?

Many digital cameras come with a cord that lets you connect them directly to a television through the video socket that most flat-screen models now have. The camera must be set to the appropriate video output standard (NTSC in North American, and PAL throughout most of Western Europe). You can then view the contents of the camera's memory card on a large screen.

Outputting images in this way quickly exhausts a camera battery, so use an AC adapter to power the camera for prolonged use. Or use your computer to output downloaded image files to the television with the proper connecting cable. You are limited by the number of pixels needed to fill the screen, so the definition may not always look the best—but that is set to change with the availability of HDTV (high definition television) and as more cameras come equipped with an HDMI (high definition multimedia interface) connector.

DVD players allow you to play photo CDs and DVDs, and Photoshop Elements lets you create professional-looking slide shows in the universal Adobe PDF format that you can burn to DVD—the program will adjust picture size to fill screens of different aspect ratios, and you can zoom in or out using the remote control of the DVD player.

Slide shows ▶
Putting your pictures on DVDs to exhibit as slide shows on the television screen is a great way of displaying them to family and friends. Making a slide show is simple with many programs, such as Photoshop Elements—just go to File > Automation Tools > PDF Slide Show.

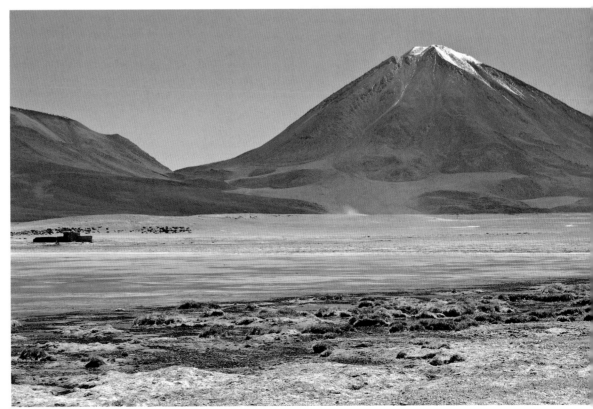

Photo © Rhod Davies

How do I create a slide show?

The universal PDF format allows you to create slide shows from just about any picture collection in an image-processing program. In Photoshop Elements, go to File > Automation Tools > PDF Slide Show. This command allows you to set delays or provide a repeat loop. Many people use the facilities available in Microsoft's Powerpoint, especially if their work has brought them into contact with making presentations through this medium.

Some programs, such as iPhoto for Macs, allow different kinds of changes between slides— dissolves, droplets, and so on, plus synchronization to music. These slide shows can be saved as a Quicktime movie and burned to a DVD.

In general to create a slide show, browse and select the desired image files from their folders to create a list in the program's dialog window. These image files can be previewed and you can arrange them in any order you choose. You can break up the sequence by creating title shots in any suitable program and then save as JPEGs. Next, you can decide how to move from one image to the next by varying the speed of transition and also the time for which an image stays on screen.

If you take time to think how images follow one another, of the way colors can be used sequentially, and about the composition of shapes in the pictures and so on, you can create a slide show that will impress your friends. You can set it to music, add your own commentary, and create records of memories for future years.

◀ **Making a slide show**
Using an image-processing program such as Photoshop Elements to construct a slide show is like following a step-by-step recipe. Burn slide shows of your favorite family shots to a CD or DVD and you can show them to friends and other family members anywhere there is a DVD player connected to a TV screen.

Can I project my digital pictures as I did with 35mm slides?

A digital projector effectively takes what you see on your computer's monitor and projects it for display during lectures or presentations. You can project single images as you open them on your computer screen, or you can be more adventurous and use the slide show options available in many programs (Photoshop Elements or iPhoto, for example). Or incorporate your images into full scale presentations with PowerPoint®.

The image on a monitor is viewed at 72 dpi, which breaks up somewhat when projected, so it helps to sit some distance away to view the image. It is worthwhile to use your own if you lecture regularly because you are familiar with it. Don't rely blindly on in-house equipment—maybe spend a little time before a talk checking things out. Having such things as contrast, brightness, and color properly pre-adjusted for the projector can make a world of difference.

If you do purchase a digital projector, it can also be used to project DVDs and create a home cinema or, for users of iTunes, light shows synchronized to music through the 'Visualize' function.

Photo © Rhod Davies

Digital projection ▶
The same slide show that you create for television can be viewed by a bigger audience if you output to a digital projector. You can create a complete entertainment package, perhaps showing your latest nature shots or travel photos with music fades, effects, and titles using a standard program such as Microsoft PowerPoint®.

Photo © Rhod Davies

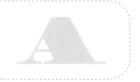

I want to email pictures to my friends. What is the best way to do it?

Email was designed to send and receive text, but you can also send pictures as attachments using any email program.

You will want to know where the image is located in your image filing system. After opening your email program and composing the text, look for the add attachments option (with a small paperclip icon). Clicking this brings up a browser that lets you find the pictures. Click on the titles to attach them to the email and you are ready to send.

With a broadband connection there are fewer problems sending large files, but you may encounter difficulties when sending large files to recipients who still use ordinary telephone lines for digital delivery (56 Kbps modem), or if they have restrictions on the capacity of their mailbox. Keep files small and attach only a few at a time to assure quicker communication—small image files appear quite nicely on a computer screen since computer displays need only 72 dpi (and consume little storage space).

top tip

When you send files to view on screen, they need only be 72 dpi (screen resolution). You can make them look better by applying Unsharp Mask at 80% (no more), with the radius set at 1.5, and threshold at 8 or more (see page 112).

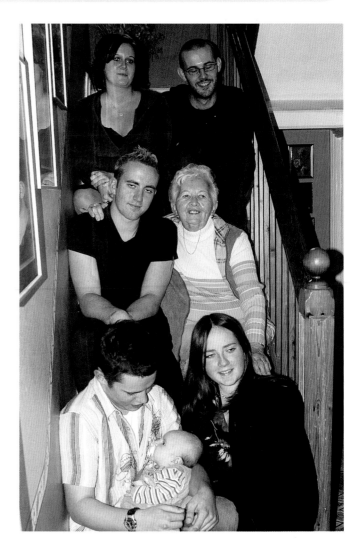

▲ **Share your experiences**
Sending pictures by email is a great way of keeping in touch with friends and family, especially when you are traveling. Pictures can be attached to any regular email program via the attachments menu and you can keep people up to date with what you are doing.

How can I put my pictures in a newsletter, brochure, or even a book?

Desktop publishing (DTP) has placed the production of professional-looking materials such as brochures, newsletters, and even books, into the hands of anyone who owns a computer. You can easily create brochures and leaflets at home, but for larger print runs it is often more cost-effective to burn the material onto a CD and take it to a professional printer to create the finished product.

DTP programs allow you to design publishable items by arranging pictures and different kinds of text. There are numerous packages available, from the top-end professional systems such as Quark®, In-Design®, Microsoft® Office Publisher for PCs, and AppleWorks® for Macintosh computers, to word processing packages that let you handle pictures.

Most programs let you design your own page layouts, but it is probably easier to use one of the ready-designed templates into which you place text and pictures. You can prepare text in a word-processing program, then copy and paste into the DTP text box. Most desktop publishing packages allow you to resize picture boxes, giving you options for using your photos, even letting you move the picture within its box and then move the box to any place on the page. The more advanced programs let text flow around your pictures so that the production looks professional.

Photoshop Elements offers a Photobook option under the Create module of the program, and Macintosh users also have the benefit of producing your own books (iBooks in iPhoto). The results are superb and you can get the book printed at reasonable cost. Though often you need not go to the printing stage because a PDF file of your book or other project can be distributed via email or be downloaded from a website.

▲ Producing books and leaflets

The production of books, magazines, and brochures can be totally managed by your computer. With a little practice, anyone can produce professional-looking material. Two useful tips are worth keeping in mind: Never be afraid to leave white space (filling every page creates the impression of clutter); and never use too many different typefaces in one document.

How do I put pictures on the web, and how can I decrease upload/download time?

The ability for folks to place their photos on the web has changed dramatically over the past several years. Many websites allow you to rent space, along with providing some sort of content management system that permits you to easily upload material and keep your site up to date—whether you have designed the site yourself, paid to have one designed, or bought an off-the-shelf package.

One great feature in a host of image-processing programs is the ease with which you can put together web pages of images in ready-made templates (many of which also allow you to re-size and re-position). In Photoshop Elements, the Web Photo Gallery option is available under both the Create and Share modules. Click and a dialog box appears that offers a wide array of designs for a web page.

Re-sizing photos is managed automatically with the Web Photo Gallery option, and so is optimizing files so that they load quickly on the web while still looking bright and detailed. For computers with small-to medium-sized screens—typically 15 inches—images are sized to fit into an on-screen browser window. 640 x 480 pixels is typically the size of images you can use with a 3:2 aspect.

A web page is not just one big picture file filling the screen, but many different files displayed simultaneously, with each item precisely arranged using HTML (HyperText Markup Language). Thanks to templates, you can avoid the complications of using HTML.

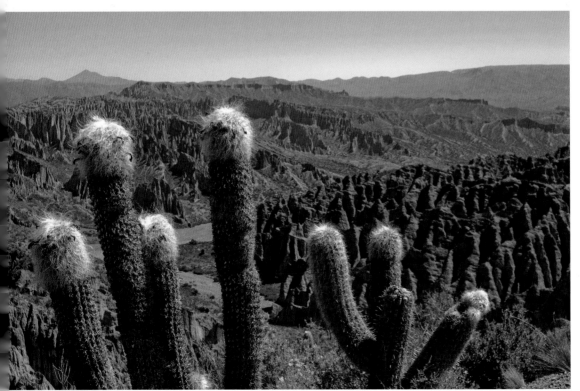

Photo © Fran Yeoman

◄ **Preparing batches**
Image-processing programs such as Photoshop Elements let you automate the task of resizing when you have lots of images you want to place on the web.

▲ Creating a Web gallery

A dialog box allows you to preview and choose Styles for a webpage and to set such things as picture size and resolution. The program automatically re-sizes and optimizes pictures for web use, allowing you to experiment before uploading.

▲ Displaying Web gallery

The program constructs a fully operational webpage so you can see your gallery of images—here the style chosen gives thumbnails along with a larger single image. Click on any one of the thumbnails to make it display larger.

Images for Web displays ▶
I use images resized to 600 x 400 pixels for web displays, then sharpen slightly (unsharp mask 80%; radius 1.5, threshold 8) and save as JPEGs at a moderate compression level.

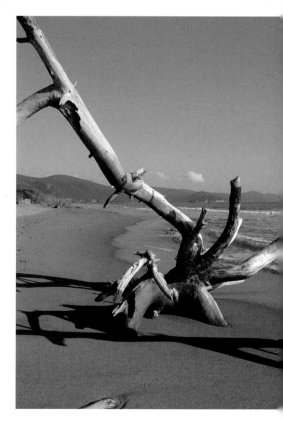

Once your web template is completed, you are ready to upload to a website. The computer codes everything in HTML, sending the data into cyberspace to the server of the company that will host your website; there you and others can access the pages. Images are generally compressed either as JPEGs (for pictures) or GIFs (for graphics); both are lossy, which means that some data is lost when the file is first compressed.

index